IMAGES
of America

ANNISTON

IMAGES
of America

ANNISTON

Kimberly O'Dell

ARCADIA
PUBLISHING

Published by Arcadia Publishing
Charleston SC, Chicago IL, Portsmouth NH, San Francisco CA

Printed in the United States of America

Library of Congress Catalog Card Number: 00-104884

For all general information contact Arcadia Publishing at:
Telephone 843-853-2070
Fax 843-853-0044
E-Mail sales@arcadiapublishing.com
For customer service and orders:
Toll-Free 1-888-313-2665

Visit us on the Internet at www.arcadiapublishing.com

When I worked on Calhoun County, I was fortunate to meet and work with some wonderful people.
I was again privileged to have the aid of many of those same people while working on this project.
I would like to thank the following:

The Calhoun County Public Library's Alabama Room,
for allowing the Alabama Room Originals Photograph Collection to be used for this book;

Tom Mullins, Kaye Oliver, and Linda Dukes, whose assistance was invaluable;

Mrs. T.E. Kilby Jr., who was kind enough to share some of her private photographs;

Oxford Blueprint and Reprographics Inc., for reproducing the Anniston map;

my editor, Katie White, who suggested this book and then worked tirelessly to get it to press;

my friends, for their suggestions, support, and encouragement;

and to my family, I want to express my love and appreciation for everything.

CONTENTS

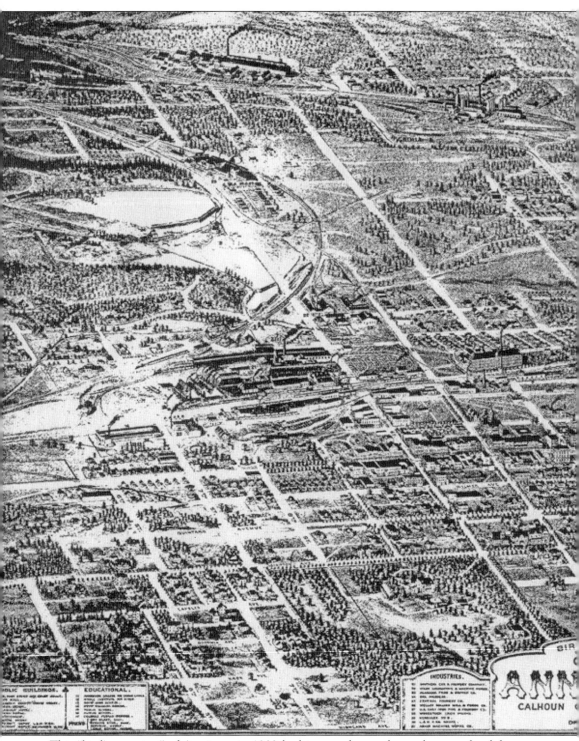

This "bird's-eye view" of Anniston in 1903 looking northwest shows the growth of the town in the 20 years since it opened to the public. The iron ore beds (far left) were the focal point for the building of the town. The Tylers and Nobles built their homes on the east side of town

(bottom center). Anniston has changed over the years, but the layout of the streets is virtually the same as when the town was originally laid out by John Forney in 1883. (Courtesy of the Alabama Room at the Calhoun County Public Library.)

INTRODUCTION

Calhoun County, incorporated by the state of Alabama in 1832, has a population of roughly 117,000, and is situated in the Choccolocco Valley at the southern tip of the Appalachian Mountains. The valley sits approximately 900 feet above sea level, and is noted for its mild winters. The area is drained by the Choccolocco, Cane, and Cold Water Creeks, thus forming a region rich in minerals and good for farming. The county seat was situated first in Jacksonville and then removed to the city of Anniston in 1900.

The town of Anniston, AL, was not officially founded until 1872; however, inhabitants of that tract of land in Calhoun County can be traced back many centuries. Creek Indians settled in this area of Alabama and were first visited by whites during the 1540 expedition of Hernando De Soto, who passed through the Creek land during his exploration of the Southeast. In the early 1800s, many white settlers moved from South Carolina and Georgia to settle in the rich farming land in the area. The Treaty of Cussettan was signed in 1832 by which the Creeks ceded their land to the federal government. By 1836, the majority of the Native Americans in the area were on a forced removal to Oklahoma. The signing of this treaty opened up much of Alabama for settlement. Benton County, later Calhoun County, was incorporated from land ceded in the treaty in 1832.

The area around present-day Anniston was mainly farming land with the two main crops of cotton and corn. Farming remained the major business in all of Calhoun County until after the Civil War. The area around Anniston did find a use during the war as an iron company for Confederate munitions. In 1862, D.P. Gunnels of Oxford sold land to the Oxford Iron Company, which located the Confederate iron furnace on Cane Creek. Residents called the land "Pine Ankle" because of the dense pine forests near the iron furnace. By April 1863, the furnace was in operation, but it was destroyed in a Union raid in 1865 and never rebuilt

At the same time Pine Ankle was dormant, the Noble Brothers iron works in Rome, GA, was looking to rebuild and expand after the war. The Noble family, primarily Samuel Noble, purchased the land around the old Oxford Furnace. After the Civil War, many Northern capitalists were eager to invest in the South. In 1872, Samuel Noble was visiting the office of Alfred Tyler of the South Carolina Railroad to sell his family's iron car wheels. It was in this office that Noble met Alfred's father, Gen. Daniel Tyler. Noble and the elder Tyler discussed the presence of iron ore in Alabama and Georgia and the prospect of building an iron furnace. A short time later. Tyler and Noble visited the old furnace site, and on May 4, 1872, they, along with Tyler's sons Alfred and Edmund, and Noble's father, James Sr., and brothers John and William, created the Woodstock Iron Company. The name of the company was selected because of the proximity of Oxford, England, to Woodstock.

In 1873, a 50-ton charcoal furnace was built. Through good management and exceptional wares, the Iron Works survived the Panic of 1873 and subsequent depression. By 1879, a second 50-ton furnace was added. Around this time. it was discovered that there was another Woodstock, AL. To be incorporated, Noble had to find a name for his utopian experiment. He decided to name the town Annie's Town after Alfred Tyler's wife, Annie Scott Tyler. The town of Anniston, a corruption of Annie's Town, was incorporated in 1879 with an intendant (mayor) and four councilman.

After the Civil War many people wanted to reform the social ills of the day, and Noble was no different. He hoped to create a "model city" to avoid the slums and overcrowded conditions of many Northern industrial cities. To this end he built cottages for the iron workers with yards and gardens, tree-lined streets, a company store, and a farm to produce food. Education and religion were stressed in the company town and both a school and episcopal church were founded almost immediately. Anniston, with a population of less than 1,000, was a closed city and under the company's complete control. In May 1880, The Anniston Manufacturing Co. was created to employ the wives and children of the laborers at the iron company.

On July 3, 1883, Anniston was officially open to settlers, who soon caused a building boom. Anniston was now an iron and textile town. Another building and population boom occurred in the late 1880s. Almost every major religious denomination was represented in Anniston by 1892, and the population had swelled to almost 10,000. The Panic of 1893 did cause business failures in the town. One of the banks closed and Woodstock Iron Company tried reorganization, but the company eventually failed.

In 1899, a county-wide election was held and Anniston won the right to be the permanent site of the Calhoun County Courthouse. Anniston's growth continued during the early years of the 20th century, and by 1910, the population had reached 12,794. Noble Street was the main street going through Anniston, and to its west was the industrial factories of town. Quintard Avenue was largely residential with wide streets and a tree-lined median.

In 1917, the federal government acquired the land for a military post just north of Anniston. The Anniston Chamber of Commerce signed a contract on March 17, 1917, for the purchase of 18,972 acres of land. Camp McClellan became an active post in August 1917 when troops moved in to help complete construction of the camp. In 1929, the military base was reclassified as a fort. Many soldiers who trained at the fort through the years spent much of their leisure time on the streets the Anniston.

By 1920, Anniston was second in freight tonnage in Alabama. The town also had 12 public schools and 2 private institutions of higher learning. In addition were 5 banks and 9 textile mills. The iron industry in town produced everything from pig iron to boilers and engines and was the largest producer of cast-iron soil pipes and fittings in the world. The town also had a grain elevator, several ice companies, and 2 creameries. The population had grown significantly and reached almost 18,000 in the 1920s.

During the Great Depression, the city faced tough times. However, Mayor W.S. Coleman made sure the city's credit rating remained good. Coleman also made sure the city employees were paid eventually. It was during this era that the city changed from a mayor-council system to the city commission system of government. In 1938, Anniston also acquired its first radio station, WHMA. Owned by Harry Ayers, the station went into limited operation before going on air full time the following year.

One of the major aids that helped pull Anniston out of the depression was the government's decision to build the Anniston Ordinance Depot nearby in 1942. The depot was located 7 miles west of Anniston in Bynum, since this location would displace the fewest number of families. During World War II, Pelham Range was acquired by Fort McClellan for use in training for artillery, tank, and heavy mortar firing. During war time, the population of Anniston swelled to close to 68,000.

By the 1950s, families had access to automobiles and moved away from the mill village to the suburban areas. The town shifted to the east and Quintard Avenue became the main thoroughfare

through town. The population had dropped from the war time high to approximately 31,000. Noble Street, once the hub of the city, was beginning to slowly decline. By 1951, Quintard was opened from Twenty-Second Street to the north and allowed a quick route to Fort McClellan and Jacksonville. By 1958, the southern end of Quintard Avenue was opened to the city limits of Oxford.

During the 1960s, Anniston was at the peak of its population growth: 33,657 people. The Vietnam War also brought work for Anniston Ordinance Depot. Soldiers at Fort McClellan also increased during the period. Despite the prosperity, Anniston had its share of racial strife in the Civil Rights Movement. The major incident was on Mother's Day, 1961, when a Freedom Rider bus that was on a campaign to integrate busing in the South was burned just outside of town. As a result of this, frustrated Anniston ministers, both black and white, decided to meet once a month in secret to discuss issues. In 1963, the city of Anniston formed the Human Relations Council, a biracial council born out of the ministers meetings. The council met to deal with race relations, and consequently, the integration of Anniston was relatively bloodless compared to other Southern towns.

In 1972, the Alabama Shakespeare Festival was started and was the only classical repertory company between Dallas and Washington, D.C. Anniston's progressive thinking earned the city the distinction of being named an All-American City in 1977.

Amid the prosperity, Anniston faced some set backs. In 1986, the Shakespeare Festival moved to a state-of-the-art facility in Montgomery. Fort McClellan closed in 1999. As Anniston faces the 21st century, many more changes are ahead. Change, however, has been a part of Anniston's story since Samuel Noble created his "model city" in 1872.

Author's Note: Unless otherwise specified, all pictures are courtesy of the Alabama Room Originals Photo Collection at the Calhoun County Public Library.

One

THE EARLY DAYS

Anniston's first settlers were the Creek Indians. The first recorded contacts of the Creeks was found in the expedition of Hernando De Soto in 1540. The Native-American population in Anniston during the 16th century did not likely exceed 2,000 people. They lived in towns that ranged in population from 100 to approximately 1,000. Most activities were done in common, where everyone worked for the good of the group. Individual houses had garden plots nearby, but a town plantation consisting of common fields was marked off in household tracts that were planted in rotation. Once the fields were exhausted, they were abandoned.

Creek towns were moved frequently due to soil exhaustion. People lived in wood frame rectangular houses with curved roofs that were either thatched or had bark shingles held down with poles. The sides of the houses were whitewashed wattle and daub walls, which were upright poles interwoven horizontally with sticks covered with mud.

The life of the Creeks continued on much the same path until white settlements became more prevalent. On March 4, 1832, the federal government signed the Treaty of Cussetta with the Creeks, whereby the Creeks surrendered their sovereignty of the lands to the government. In 1836, the remaining Creeks were forcibly removed to Oklahoma by military troops leaving the land for white settlers from Georgia and South Carolina to settle.

The site that would become Anniston was sparsely populated, primarily with farms, before the Civil War, but the area was ripe with mineral resources. In 1858, Alabama state geologist Michael Toumey published his report describing the condition of the county's ores, particularly hematite ore and limestone. Hematite ore was necessary for the manufacture of pig iron and this report influenced the Confederacy to locate an iron furnace on the site of Anniston.

The Oxford Iron Company was organized September 23, 1862, with $24,000 capital stock, much of which was provided from local sources. The Confederate government granted part of the necessary funds for building the furnace and structures for the manufacturing of pig iron. These funds were repaid in shipments of iron ore.

By April 1863, the furnace, built on 825 acres, was in operation and produced almost 20 tons of charcoal pig iron daily. The Confederate government provided skilled iron workers and slave laborers that were used for all manual labor at the furnace. The company negotiated for a fixed amount of tonnage of pig iron per month with a large portion shipped to the Confederate naval yard and the army arsenal in Selma. The iron ore was shipped from Blue Mountain by the Alabama and Tennessee Rivers Railroad (later the Selma, Rome, & Dalton line). During a Union raid in April 1965, the iron works was defended by Brig. Gen. Benjamin J. Hill, CSA, but Union general John Croxton still managed to destroy it. It was never rebuilt.

The Civil War effected the Noble Brothers' iron works in Rome, GA. The Nobles were looking for resources for their iron furnaces. After the war, Samuel Noble, along with two investors, purchased the land around the old Oxford Iron Company. Eventually, Noble bought out his partners so that he was sole owner of all the land. In 1872, he was in the office of Alfred Tyler selling his family's car wheels and met Alfred's father, Gen. Daniel Tyler. They discussed the merits of iron in the South. Samuel Noble told General Tyler of his acquisition of the land in Anniston. After meeting and surveying the sight, the men, along with the Tyler and Noble families, created the Woodstock Iron Company.

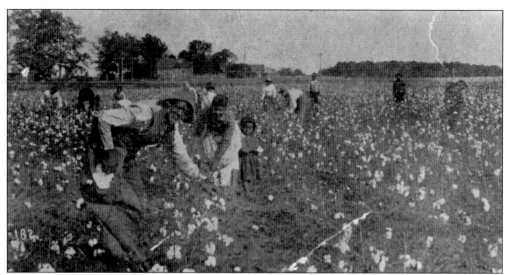

The land in the central part of Calhoun County had good, fertile soil that was ideal for farming. Most of the farming community grew two money crops: corn and cotton. Plowing was done by mules, and cotton was picked by hand. Farming remained the major business in Calhoun Country until after the Civil War. After World War II, farming changed since cotton was no longer "king." Soybean crops took cotton's place and mules were replaced by tractors and other farm equipment.

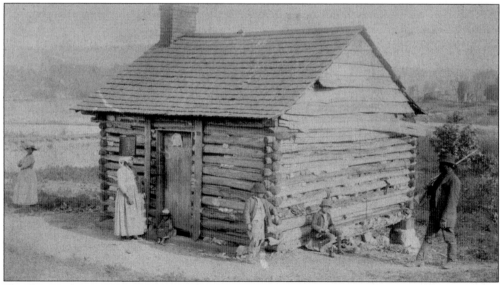

The first settler to arrive in present-day Anniston was James Teague and his wife. When they arrived in 1828, the area was sparsely populated by Creek Indians. When the Creeks were removed through a treaty in 1832, more settlers arrived. During the Civil War, the area was used as the Oxford Iron Furnace until it burned. Farmers tried to harvest the mineral rich land without much success. Anniston was sparse farming land when Samuel Noble arrived in 1872. Reportedly the first house in Anniston (shown above) was located near Twelfth and Noble Streets. An African-American family resided in the old one-room log cabin when Anniston was a fledgling town. The rest of Noble Street was filled predominantly with fields and a few homes. The closest general store was in Jacksonville, about 12 miles north.

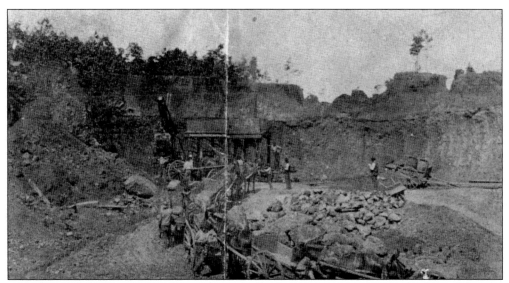

Anniston and the surrounding Choccolocco Valley were part of a mineral rich region. The iron ore beds were high-quality brown hematite iron ore, which was necessary for the production of pig iron. Some small-scale mining had occurred in the area starting around 1843, but Alabama state geologist Michael Toumey was the first to report, in 1858, the quantity and quality of the minerals in Calhoun County. According to Toumey's report a large bed of brown hematite was located about 2.5 miles above Oxford. The bed ran for several miles and was roughly 12 to 15 feet thick. The vast deposits made the land extremely valuable. These mines were used by the Oxford Iron Furnace in the 1860s and the Woodstock Iron Furnaces in the 1870s.

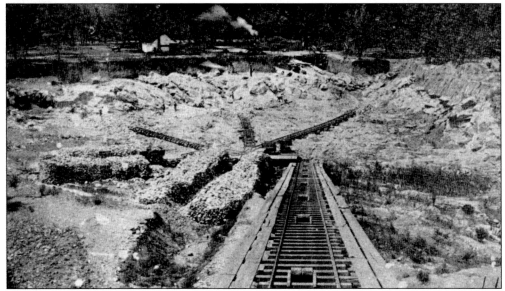

Michael Toumey stated in his geological report that magnesian limestone deposits in Calhoun County were located roughly on the surface of the ground. Lime, along with ore, was a necessary ingredient to produce pig iron. Toumey found that at the southern extreme base of Choccolocco Mountain there was a large deposit of silurian limestone. In addition to the limestone and hematite iron ore, the report also stated there were specimens of manganese oxide present in Calhoun County.

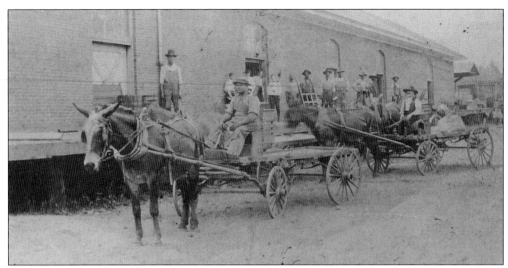

The first railway to run tracks through Anniston was the Alabama & Tennessee Rivers Railroad. The tracks were completed from Selma to Blue Mountain in 1861; however, the rest of the line was abandoned because of financial difficulties and a shortage of iron. The company considered the line important and prepared to take it to Rome, GA. After the Civil War, the line was completed, and in 1866, the name was changed to the Selma, Rome, & Dalton Railroad. The line was extended to Dalton, GA, in 1869. The freight depot was in the Comer-Maddox Building at Tenth Street and Moore Avenue and also handled passengers from there for a time. This depot eventually became the Southern Depot with mergers of the Selma, Rome, & Dalton, and later the Georgia Pacific, to complete the consolidation of many smaller railroads under a larger, more experienced and efficient organization.

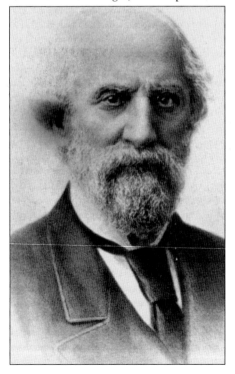

Daniel Tyler was born January 7, 1799, in Brooklyn, CT. He was the great-grandson of Puritan minister Jonathon Edwards and in 1819, after attending both public and private schools in Connecticut, he graduated from the U.S. Military Academy at West Point and entered the military service. Tyler married Emily Lee in 1832, then two years later he resigned his commission in the army to enter the business world. After the failure of his iron furnace business, Tyler concentrated his efforts on rebuilding and refinancing railroads. At the outbreak of the Civil War in 1861, Tyler was re-commissioned in the Union Army as a brigadier general, where he served until 1864, when he resigned his commission. In 1872, an agreement was signed between the Noble and Tyler families to form the Woodstock Iron Company. General Tyler, however, did not live to see the opening of the town to the public. He died in New York on November 30, 1882. His funeral was held in the foundation of Grace Episcopal Church, which he was instrumental in building, and he was buried at Hillside Cemetery overlooking the city of Anniston.

On November 22, 1834, Samuel Noble was born to Jennifer Ward and James Noble Sr. in Crowan Parish, Cornwall, England. In 1837, the family moved to Reading, PA, where James was involved in the iron industry and Samuel was schooled. By 1855, the Noble family had moved to Rome, GA. James Sr. established a foundry and rolling mill in Rome, and Samuel was the secretary-treasurer of the company. Matilda Christine Stoeckel of Philadelphia married Samuel in 1861. By 1863, Samuel was the superintendent of the Cornwall furnace. After the Civil War, the Noble family was in need of large iron ore deposits to use in furnaces in Rome, GA, and Cherokee County, AL. Samuel had heard about the Oxford Iron Furnace and the nearby ore deposits where there were still undeveloped iron ore deposits. Samuel and two partners started buying the land around the old furnace. Eventually, Samuel borrowed money from family friend Charles Quintard and bought out his partners to be the sole owner of the land. On April 24, 1872, incorporation papers were filed in Rome, GA, which created the Woodstock Iron Company. Samuel was largely responsible for the layout and creation of Anniston. He died suddenly on August 13, 1888, most likely of an intestinal disorder or food poisoning. The entire town was draped in mourning at the loss of its founder. His funeral was held in Grace Episcopal Church and he was buried in Hillside Cemetery. No eulogy was said at the funeral or the grave.

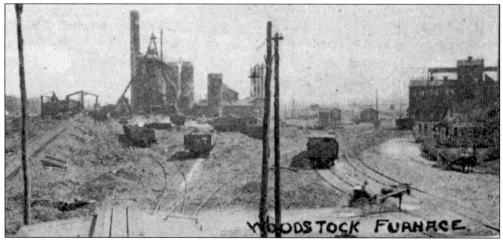

The Woodstock Iron Company was set up with a $75,000 capitalization divided into 750 stock shares of $100 each, with the Noble and Tyler families receiving 375 shares apiece. Alfred Tyler was made president of the company with Samuel Noble as secretary-treasurer. Given the Tyler family background in railroads, Daniel Tyler negotiated with the Selma, Rome, & Dalton Railroad to haul out the iron. The iron company went to Europe for the first employees. The company brought stone masons, brick masons, and furnace men from England, in addition to hiring charcoal burners from Sweden to cut the trees to use for fuel in the furnaces. The furnace, located at the end of Gurnee Avenue and Ninth Street, was constructed around the clock by Anniston workmen so that the first furnace was blown in on April 13, 1873. (Courtesy of Anniston Chamber of Commerce Booklet at the Calhoun County Public Library.)

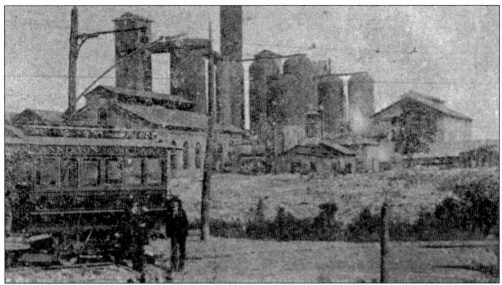

In February 1879, a second charcoal furnace was blown in. The iron company faced financial problems, so in December 1885, the company was reorganized as the Woodstock Iron and Steel Company with Alfred Tyler as president. Two years later, the company reorganized yet again, and changed back to the Woodstock Iron Company with Tyler retaining the presidency of the company. That same year, construction started on two coke furnaces to replace the coal furnaces (shown above). To ensure a constant fuel source, the Blockton Coal Mines were purchased. The coke furnaces were built at Fourteenth Street and Clydesdale Avenue. In 1889, the company had to borrow money, and when the loans could not be repaid, the property was foreclosed and auctioned to northern investors, but even this could not save the company. It remained under local management, but the debt continued to increase and eventually the company was a causality of the Panic of 1893. By 1900, the charcoal furnaces were dismantled and the property used for Adelaide Mill. The coke furnaces were operated sporadically until about 1912 and then dismantled.

The iron ore deposits were extracted from a slope on Coldwater Mountain. A steam-operated shovel loaded the hematite ore directly onto two-wheel mule drawn carts, which then transported the ore to the Woodstock Iron Company's furnaces. One of the problems that led to the demise of Woodstock Iron was that the natural iron ore resources were used up. The company faced high expenses when iron ore supplies had to be shipped to Anniston.

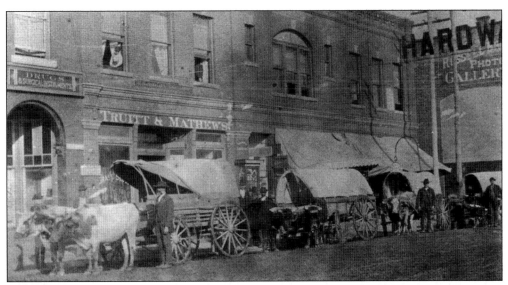

Transportation in early Anniston was limited to foot power. Many who came to this area in the early years came by means of ox wagons (shown above in the 1000 block of Noble street). As late as 1860, the only transportation routes were two crude dirt roads. The Jacksonville Road, later a portion of Noble Street, ran from north to south. The second road ran east through the mountains and into Oxford. This road provided the only commercial transportation since a stage coach line ran on the road to Oxford. Trains arrived in 1861, when the Alabama and Tennessee Rivers Railroad was completed from Selma to Blue Mountain, AL, which passed through present-day Anniston. By 1880, Noble Street ran through the middle of the small town. Ninth Street went east from Noble for three blocks and stopped at the entrance to the Alfred Tyler Estate (present-day Regional Medical Center). Tenth Street started at the ore beds in west Anniston and went eastward to Hillside Cemetery. At this point, a rough road went over the mountain to the coaling forests. The town roads were surfaced with slag from the furnace and screenings, where ore was calcined with limestone.

In the 1870s, very little was not company controlled. According to Gen. Robert Noble's memoirs, on the west side of Noble Street, at about Eleventh Street (the present-day Security Bank building), S.A. Tuttle lived and maintained a bake shop (shown here) that eventually accepted company script as payment. Tuttle was also a gardener for the Woodstock Iron Company. Just north of the bake shop, Tuttle's son-in-law maintained a private drug store. Around present-day Twelfth and Noble Streets, Bill McKinney operated a wheelwright and blacksmith shop.

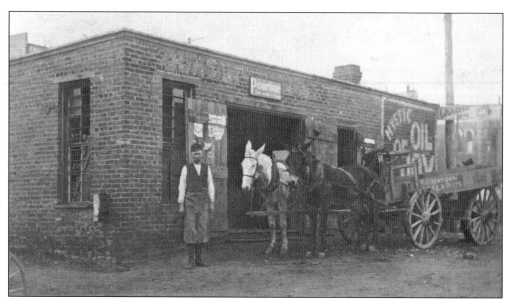

Blacksmiths were vital members of their communities since they were all-purpose repairmen. Making horseshoes was only part of their job; they also made and repaired metal parts for carriages and wagons, hardware such as hinges, and all types of tools. The blacksmith shop shown here, located at 120 West Eleventh Street, was equipped with a forge where a piece of iron was placed to make the iron malleable. Once the iron was hot, the blacksmith pulled the iron from the fire with metal tongs, placed it on an anvil, and crafted the object with a hammer. Blacksmiths were in less demand when automobiles developed in the 1920s; however, in Anniston, blacksmiths remained until around 1955 and primarily shoed horses.

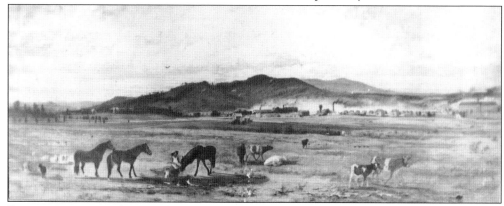

From 1873 to 1879, the Woodstock Iron Company cultivated a farm to feed its workers, even though the farm operated at a loss of about $6,000 a year. It encompassed over 200 acres and 23 houses and barns. The fields and farmhouse, located near Sixteenth Street and Quintard Avenue, were maintained by a series of foremen including "Buck" Caldwell and I.S. Gillidge. Corn, wheat, clover, hay, and other grains were grown for workers and their families. Extensive hay and grain crops were also grown by the farm for the company's herd of mules, which were used to haul coal and iron. Beef and dairy cows were kept in enclosed pastureland for the company's herds, flocks, and stock. The company hired a butcher from Philadelphia to provide the best cuts of beef, mutton, sausage, and head cheese. In addition to the ranch animals, the company maintained 200 work horses and mules. The 1882 C.H. Sherer painting above shows the town looking west from the Noble home on Thirteenth Street.

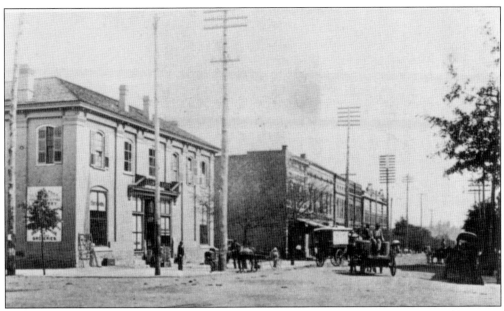

The intersection of Tenth Street and Noble was the hub of Anniston, but most of Noble Street was residential. Woodstock Iron built a commissary (left) at the southeast corner of Tenth and Noble Streets. The 120-by-60-foot structure was stocked with $100,000 worth of merchandise. The interior of the store had a large depot stove in the center of the floor in the rear of the store room. This brick building was also used as a meeting place for the men. In the 1880s the commissary was taken over by the Ullman Brothers store and in the 1920s it became the site of the Liles Building, present-day AmSouth. At the opposite end of the east side of the 900 block of Noble Street was the Mobile Block, built by a group of investors from Mobile. The Mobile block from the 1920s to the 1950s was the site of the Jitney Jungle grocery store. At the southeast corner of Ninth and Noble Streets, the iron company bookkeeper, W.L. Little, lived in a two-story brick home. The company doctor, Dr. Henry, who replaced Dr. J.W. Guin (who died in 1877 from a disease he contracted at work), lived on an adjoining lot. A line of small houses for white employees of the Woodstock Iron Company, which ran south along Noble at approximately Seventh Street where the road curved southward, was known as Cottage Row.

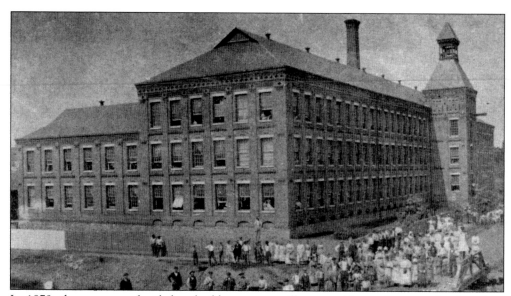

In 1879, the company decided to build a cotton mill to provide employment for the wives and children of the iron workers, as well as to diversify the town's economy. The Anniston Manufacturing Company was organized with $135,000 capital in September 1879, but did not produce the first yarn until January 1881. "The Old Mill," built at the end of Twelfth Street, was the largest cotton mill in Alabama at the time of its construction. Alfred Tyler was the president of the company and J.B. Goodwin was the manager. The plant was a three-story brick building connected to four fireproof warehouses. The mill was steam-powered and had a machine shop, carpentry shop, and blacksmith shop with a storage capacity of 18,000 bales of cotton. Anniston Manufacturing was self-sustaining except for the raw materials. The plant included a picker room, card room, spinning room, slasher room, and weave ship. Safety was paramount. The building was equipped with automatic water sprinklers and two fire plugs with individual hoses on each floor. The grounds were also equipped with several fire hydrants. The mill produced sheeting and shirtings. The mill grounds were well kept and supplied with flower beds and rare plants. Anniston Manufacturing went through several owners and the last owner, Chalk Line Manufacturing, declared bankruptcy in 1993. The mill was salvaged and torn down in 2000.

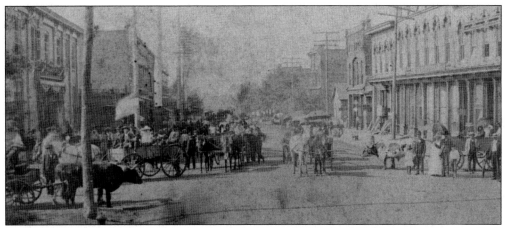

In the early days of Anniston, the west side of the 900 block of Noble was undeveloped. A spring was at the southwest corner of Tenth and Noble Streets, the site of the Noble Theater. The Maddox house, between Eighth and Ninth Streets, was a stage house that existed before the Woodstock Iron Company bought the land. This stage house was Samuel Noble's first residence when he arrived in Anniston. By 1885, the west side of the street consisted of the Joseph Mangus and Co. Liquor Company, the Noble Theater, and Dr. Frederick Gordon's office, as well as various other shops.

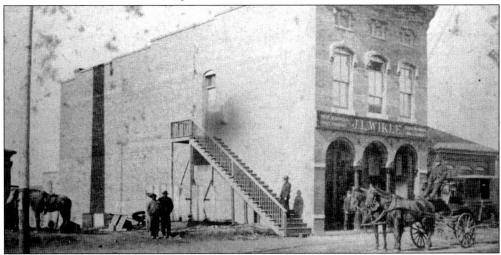

Jesse L. Wikle was born in Cartersville, GA, on May 24, 1855, and received his medical degree from the Georgia Medical School in Augusta. He used his knowledge to operate a drug store. Wikle came to Anniston in 1880 to run the Woodstock Iron Company lab. In 1883, he opened Wikle Drug at 1010 Noble Street. To the left of the store was a town well where man and beast could get a cool drink of water. The small building on the right was the approximate location of the original company lab where the company doctor kept an office. Dr. Wikle was also a founding member of Grace Episcopal Church and served on the city council, the state senate, and numerous civic boards, as well as holding the office of mayor of Anniston for 12 years. During his term as mayor, the city faced a financial crisis, so Dr. Wikle used his own money to help the city through this problem. He also was instrumental in developing the extension of south Quintard Avenue, which had been old ore beds. Wikle retired from the drug store business in 1917, but remained active in the city, spending his last years as a fixture in the lobby of the Alabama Hotel. He never married and passed away on July 25, 1940.

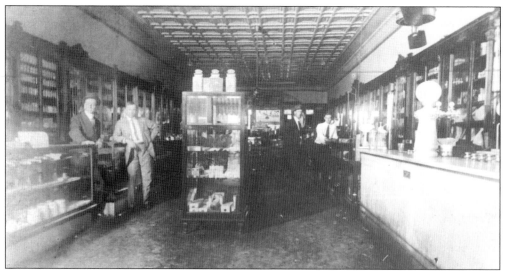

Dr. Wikle's retirement and death was not the end of the drug store that bore his name. In 1927, the store was bought and operated by J.F. and Ben Spearman. The wood-paneled store sold everything from pipes and shaving soap to candies and Buck knives. There was a soda fountain (at right) where a patron could order an ice cream, a cold drink, or a sandwich. In 1955, Edward and Ruth Spearman Scruggs owned the pharmacy. J.E. Ingram, who had started as a soda jerk at the pharmacy, began buying into the business with partners in 1961. By 1981, Ingram had taken over as owner of the pharmacy. When he could no longer find a pharmacist, Ingram was forced to sell the business to the CVS Drug Store chain and closed the doors of Wikle Drug on March 15, 2000.

Dr. Richard Proctor Huger was born on March 15, 1851, in Charleston, SC. He graduated from the Medical College of South Carolina in the 1860s. He practiced with the medical corps of the Charleston City and Marine Hospital and as an assistant at the Alabama State Lunatic Asylum in Tuscaloosa. He spent three years in Tuscaloosa at the asylum before resigning and moving to Chattanooga, TN. While in Chattanooga, he became friendly with Bishop Charles Quintard, a Noble family friend. Quintard knew that Woodstock Iron Company was in need of a company physician and suggested Huger to Samuel Noble. The company hired him as physician in 1880. He moved to Anniston with his wife, Mary Alston Huger, whom he had married in 1876, and their daughter. After Mrs. Huger died in 1881, Dr. Huger married John Ward Noble's daughter Lila. She and Huger had seven children. When Lila died in 1896, Huger married a third time to Ellen Aiken. Huger served as the city's mayor from 1887 to 1891. He died on June 3, 1922, of a massive heart attack, and was buried in Hillside Cemetery.

Two

BOOM TIME

In 1882, the Georgia Pacific Railroad (later the Southern Railway) was planning to lay tracks through Calhoun County. A group of capitalist speculators, led by A.H. Colquitt, bought the Allen Farm just south of Anniston. The property was named Oxanna because of its location between Anniston and Oxford. In June 1882, the property was laid out in blocks, similar to Anniston, by civil engineer R.M.T. Hunter. In October 1883, the capitalist group prepared to sell the lots with the expectation that the Georgia Pacific Railroad crossing would be on the Oxanna property. The founders of Anniston decided if a crossing was coming through the county it should be on their property and, as a result, contracted with Georgia Pacific to put the crossing at Anniston.

In the spring of 1883, the Anniston founders decided to open the town to the public. Before the town opened, the Woodstock Iron Company subsidized the land sales department and created the Anniston Land and Improvement Company. Gen. (Ret.) John H. Forney of Jacksonville was retained as chief engineer and surveyor of the town. Forney was assisted by the vice-president of the land company, Edward Hull. The men laid out the town into square blocks. Then the town lots were numbered and plotted on a map to be used by the Anniston Land and Improvement Company. The founders made the decision that Anniston city lots would be sold by real estate agents instead of by auction.

The official opening ceremony for Anniston was on July 3, 1883, with the editor of the *Atlanta Constitution*, Henry Grady, as the keynote speaker for the occasion. Grady, a friend of the Noble family, was given the honor of turning over the keys to the city to Mayor T.H. Hopkins. The founders advertised in newspapers that lots were for sale in the new public town. Business lots offered for sale were 30 feet wide and 120 feet deep, while residential lots were 70 feet wide and 190 feet deep. There was a rapid growth in the city within the first few months. Construction started almost immediately on 84 new dwellings, as well as stores, a city hall, an opera house, professional offices, a luxury inn, several new industries, and a railroad depot.

The town boom went into a lull in 1886 due to the failure of New York financiers that had invested in industry in Anniston. But with a reorganization, the town was soon back on its feet. In late 1886, the town needed more people so a land auction was organized. The last 2,500 acres of land held by the Woodstock Iron Company were organized into the Anniston City Land Company, whose purpose was to handle land sales. The first land auction was held January 24, 1887. The auction block was set up in the Opera House with the president of the land company, John McKleroy, as auctioneer. A large map drawn up by the company engineer, C.H. Ott, was exhibited and tables were set up in the Opera House to expedite the auction. Newspapers far and wide ran advertisements for the big land sale. The population almost doubled in the first three months of this boom time. Other land companies formed to sell the lands that were not sold prior to 1887. This second boom caught the attention of Northern industrialists, who in turn brought improvements to town.

Newspapers have been published in Anniston since 1873. *The Weekly Hot Blast* was founded in August 1883 by some of the city fathers. They hired C. Howard Williams of Columbus, GA, as the first editor. The seven-column newspaper printed articles of interests to the town. On March 26, 1885, the Watchman Publishing Company published *The Anniston Watchman*, a weekly newspaper managed by Milton Smith. The paper was printed in the Woodstock Commissary and operated until June 15, 1888, when the paper was sold by Smith. Hot Blast Publishing, who published *The Hot Blast*, reorganized in March 1887 and became a morning daily. The paper published Associated Press dispatches and was under editor James Randall of Augusta and manager Edward A. Oldham. Other newspapers printed in the 1880s and 1890s were short lived, such as James Nunnelly's *The Daily News* and James J. Mickle's *Anniston Index*. Milton Smith was not out of the newspaper business long before he founded *The Anniston Morning Times* on January 24, 1889, which was published daily and weekly. At the end of 1897, Dr. T.W. Ayers moved *The Republican* from Jacksonville to Anniston and changed the name to *The Anniston Republic*. Ayers also became editor of *The Hot Blast*. After a couple of years, Milton Smith took over for Ayers. The paper was sold to W.T. Edmondson Jr., who edited and published the paper until it was purchased by Harry M. Ayers and Thomas Kilby in 1910. In 1912, Ayers bought *The Anniston Evening Star* and consolidated *The Hot Blast* and *The Evening Star* along with the pervious mergers of *The Anniston Watchman* and *The Republic*. Today, *The Anniston Star* is one of the largest family owned and operated newspapers.

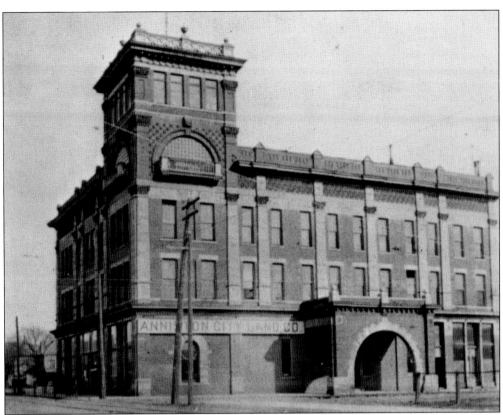

In 1883, the Woodstock Iron Company subsidized the Anniston Land and Improvement Company, with a capital stock of $1.5 million and Duncan T. Parker was president. The land sales company was deeded all the land in the city limits except the industry, that was sold by real estate agents. In 1886, Capt. John H. McKleroy, president of the Alabama Mineral Land Co., moved to Anniston to assume responsibility for the reorganized land company, The Anniston City Land Company. Co-owners McKleroy and Duncan T. Parker had a stock of approximately $2.5 million and controlled all the real estate, the Anniston Inn, the water works, lighting, and other assets. The purpose of the company was to handle sales of land, since the proprietors of Woodstock Iron found it cumbersome to be in the real estate business. On January 24, 1887, the company held an auction with some lot prices going as high as $150 per front foot. The land company at Thirteenth Street and Moore Avenue was housed in an imposing structure made of pressed brick from the Woodstock Iron Company.

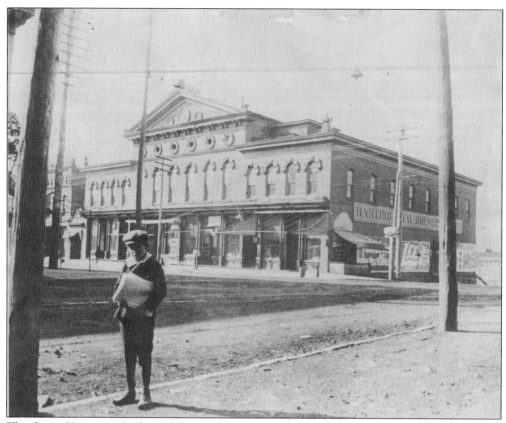

The Opera House was built on the southwest corner of Tenth and Noble Streets in the summer of 1883 by William Noble, Samuel Noble's brother. The building, completed on October 1, 1883, was reportedly modeled after the Winter Garden in New York City. The Opera House was originally located on the second floor with businesses situated below, including the newspaper, *The Hot Blast*, and the Joseph Mangus and Company Saloon. A lavish interior included scenery painted by artists from New York, an Italian fresco of Greek mythology on the ceiling, a chandelier, ornate scroll work, thick carpeting, solid-brass stairway rails, and gilded and painted plaster angels brought together with festoons of flowers. The theater building was sold to John H. Noble in September 1888. After the back wall was struck by lighting in 1908, the theater was remodeled, the stage floor lowered, and the theater enlarged to seat 1,100 people, with standing room for an additional 200. The 35-by-70-foot stage was equipped with a rolling blue and white curtain trimmed in gold lace that operated on a crank called a crab. The theater was used as a public meeting place, as well as host to everything from great operas to minstrel shows. Many famous people appeared on the stage, from Spanish American War hero Richard P. Hobson, who Hobson City is named for, to Lillian Russell. Prices for box seats in the theater ranged in price from $15 to $20, which was costly in the day. After movies increased in popularity, the Opera House was converted into a movie house around 1915. After World War II, television was the movie house's main competitor, and the theater was razed in 1958 so a more commercially viable business could use the lot.

The First National Bank of Anniston was opened on the second floor of the Noble Opera House, on September 10, 1883. The bank was founded by Samuel Noble, Alfred Tyler, and Duncan T. Parker, who was also the first president. A few months after the bank opened it moved into a new building on the corner of Ninth and Noble Streets where it remained until 1888. The bank weathered the financial panic of 1884. In 1888, the bank purchased the building at the southeast corner of Eleventh and Noble Streets (shown here), where it remained until 1973 when a modern six-floor building at 1000 Quintard Avenue was completed. First National Bank started its branch banking program in 1952. The bank ultimately became Southtrust Bank.

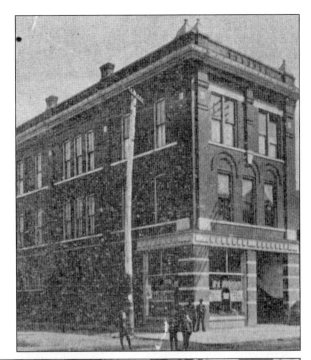

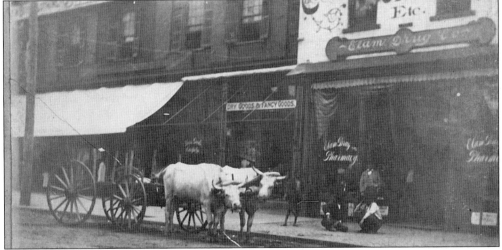

Ullman Brothers department store (at left) had its start in 1884 when Leon Ullman arrived to establish a business. The original Ullman Brothers store, a general store that sold groceries and necessities, was in the old Woodstock Iron Commissary at the southeast corner of Tenth and Noble Streets until around 1898. Leon's brother Saul joined him shortly after the store opened. Around 1912, a third brother, August, joined the family business. In 1898, the brothers relocated the store to 1112 Noble Street and made the business a general department store. The store remained at this location for about 10 years. Saul withdrew as a partner from the store around 1918 and the store relocated to 1105 Noble Street and became a ladies' clothing store. In the early 1930s, Leon and August Ullman died. In 1933, the shop was sold to longtime employee Elizabeth Weaver, who formed a partnership with Sadie and Mary Comer. In 1965, brothers Sidney and Leonard Held purchased Ullman's. The department store closed in 1980 while under the management of Sidney Held.

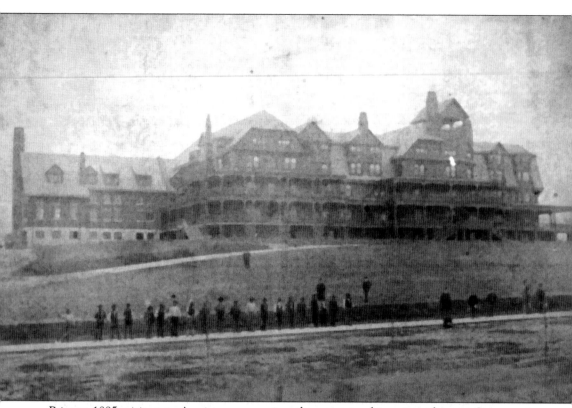

Prior to 1885, visitors to Anniston were primarily entertained in private homes. Construction on a hotel began October 14, 1883, and it was opened to the public in April 1885 as a Victorian resort. The Anniston Inn, of Queen Anne architecture, was five stories and cost $260,000 to construct. The first floor was of stone, the second was of brick, and the third through fifth were of wood. Wide verandas extended around the entire building on the first three floors. The design of the hotel has been attributed to Philadelphian George T. Pearson. The inn had 300 lights that were powered by a dynamo, and rooms were equipped with both electric and gas lights, allowing guests to choose. The hotel parlors were furnished with highly polished woodwork and elaborate draperies and furnishings. The Anniston Inn, located at Fourteenth Street and Gurnee Avenue, was under the management of Harry Hardell, a well-know Pennsylvania hotel man. A depression in the 1890s eventually forced the closure of the hotel. For a time it was a boarding school for girls, and then an apartment house. During World War I, Thomas Kilby and other city fathers thought the city needed a first-class hotel and central assembly place, so the inn was renovated and opened again as a hotel. Some of the changes were a lighted sign in front of the hotel that had "The Inn" written in script, and the porches were turned into outdoor dining rooms. Mr. and Mrs. Larry Poindexter managed the hotel. In January 1923, a fire started at 3:30 a.m. on the fourth floor, most likely from defective wiring. Many patrons on the upper floors barely escaped, and a small potion of the furniture and equipment was saved from the blaze. The east wing of the inn was the last section to burn. The replacement value of the hotel was for more than $300,000; however, the insurance only covered $60,000. With this fire, Anniston lost one of its architectural treasures.

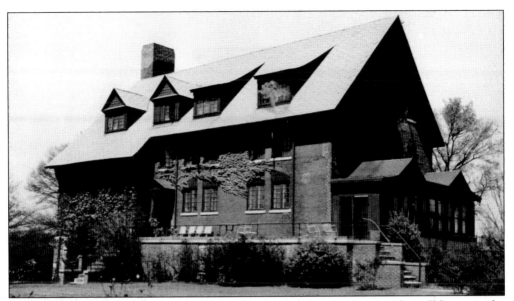

The Anniston Inn kitchen annex was saved from the 1923 fire due to a firewall between the main inn and the kitchen. The three-story brick structure housed the kitchen, the children's dining room, and the living quarters of the servants. The Axis Club, later the Women's Civic Club, leased the building around 1925 and maintained the structure. During the mid-1980s, the annex underwent remodeling and renovations.

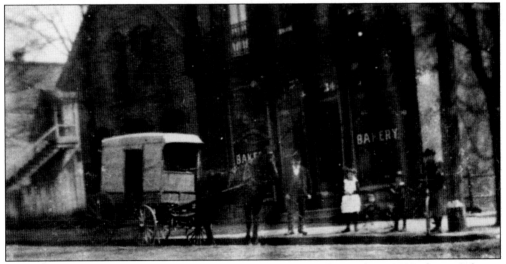

Charles Nonnenmacher (left) arrived in Anniston in September 1883 from Atlanta. Nonnenmacher, a native of Germany, was a baker by trade and settled on the corner lot at Gurnee Avenue and Eleventh Street. He paid $2,500 for the lot and built Nonnenmacher Bakery in 1887. The two-story brick building fronting Eleventh Street had three store rooms and five office rooms. The family lived next door to the bakery in a two-story cottage house built by the Woodstock Iron Company. Brick ovens used to bake goods were located in the basement of the store. Some of the baked goods popular in the store were almond macaroons, pound cakes, and light bread. Goods were delivered in a horse drawn wagon (shown above). About 1919, Nonnenmacher was in bad health and sold the bakery to E.C. Lloyd of Rome, GA, who moved it to Noble Street.

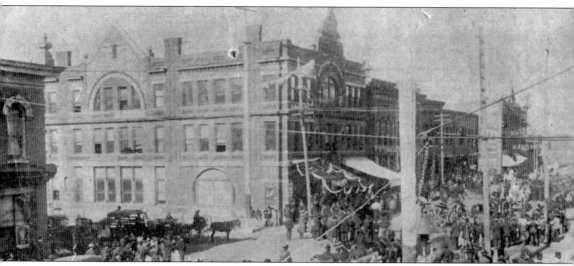

In June 1874, the Woodstock Iron Company built a flour and grist mill at the northwest corner of Tenth and Noble Streets. The mill was used mainly to grind feed for the company livestock and employees, but people from the county came also to have their flour and corn ground. The company hired an expert miller to run the mill. During the January 1887 land auction, the old mill was sold to Maj. D.F. Constantine. It was torn down and the Constantine building, an elaborate three-story brick Victorian building, was erected on the site in 1887. At the same time, Joseph Saks established his store, The Famous, in the building. By 1898, Saks had moved his store to the corner of Eleventh and Noble Streets. When Saks moved out, John Shelnutt moved his general merchandise store to this location. The Globe Clothing Company moved in around 1900, before moving across the street to the Caldwell Building around 1913. Ory's department store occupied the building until around 1922, when The Grand Leader store opened in the building. Between 1929 and 1938, several department stores occupied the building, but did not remain very long. In 1940, the building's beautiful Victorian architecture was ruined when Sears rented the building and completely remodeled the structure to make it look more modern. The top floor of the building was removed and the bricks painted a cream color. Sears moved out in 1950 and Haverty's furniture store occupied the building until 1984.

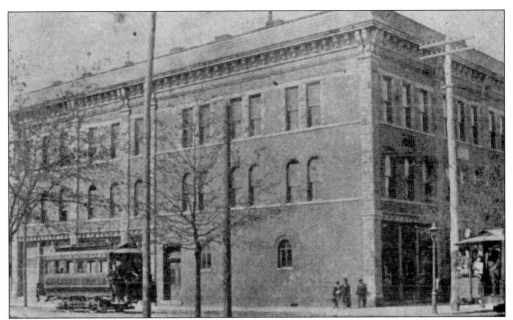

The Wilmer Hotel was located at the corner of Tenth Street and Wilmer Avenue, currently the AmSouth parking lot. The 3-story, 40-room hotel was constructed in 1888 of hand-made brick from one of the local foundries. The hotel walls were 16 inches thick and each room had a fireplace. The first floor contained a huge lobby with a tile floor and a double staircase in the center of the room. The dining room and baggage room were behind the lobby. The hotel went by many names in its years of operation. After the turn of the 20th century, it was operated as the Anniston Hotel. A bus depot eventually occupied a large portion of the lobby. By 1938, it was the Keener Hotel, a name it retained until it was torn down in the 1950s.

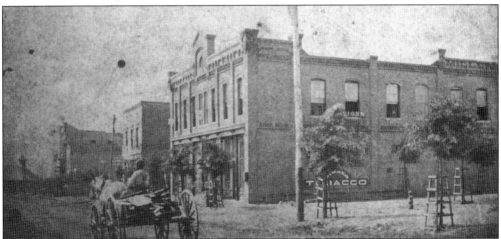

The corner of Gurnee Avenue and Tenth Street was a business district in the 1890s. Located at 101 W. Tenth Street was the Boston Store (shown above), a general merchandise store. L.H. Kaplan was the store's proprietor. A few doors down at 105–107 W. Tenth Street was Max Marcus Clothing, which stocked clothing, shoes, and men's furnishings. By 1905, Max Marcus moved into the Boston Store location and stocked furnishings, hats, notions, and trunks, among other items. Abraham Goldstein moved a clothing store into the old Marcus Clothing building by 1908.

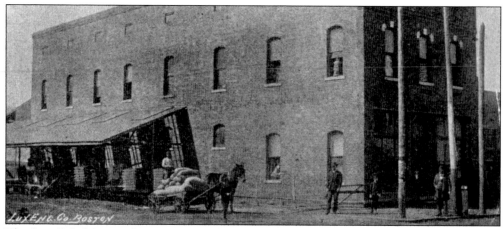

The Iron-Belt Mercantile was a two-story mercantile shop located on the corner of Gurnee Avenue and Tenth Street. The mercantile store was started about 1896 with $150,000 capital by R.J. Riddle, who served as the president of the wholesale grocery while J.R. Draper served as vice president. One of the mercantile's employees was R.W. Miller, who later organized the Miller Flour and Feed Company. By 1898, the Iron-Belt closed, but it was not empty for long. Around 1900, A.W. Bell organized Bell and Weatherly Company, a wholesale grocery. During the 1920s, the building housed Sterne-Stevens, also a wholesale grocery. Around 1935, L.M. Edwards moved in with his Edwards Cigar and Tobacco Company and stayed until 1953. The building sat vacant for a few years, and then was occupied by various stores into the early 1960s. Model City Glass moved their operations into the structure in 1966. The building was demolished in 2000.

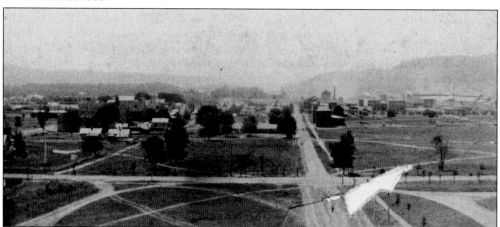

Gurnee Avenue, which ran north and south from Twenty-fifth to Ninth Streets, ending at Woodstock Iron Furnace, was named for New York investment broker, Walter A. Gurnee. Northern investors were important to Anniston in the early days. These investors supplied the capital needed to finance a town in the Reconstruction-era of the South. This view above of Gurnee Avenue was taken from Fourteenth Street looking south prior to 1900. One block to the left was a mostly residential Noble Street. To the right (in the background) was a bustling West Tenth Street, which led to the town's industries. This section of West Tenth Street was populated by both black and white merchants. Among the African-American-owned businesses were two barbers, a restaurant, a tailoring company, a bike repair shop, and Dr. Charles Thomas' drug store, the first black physician in Alabama. White business included two boarding houses, a meat market, steam laundry, crockery, and numerous dry good stores.

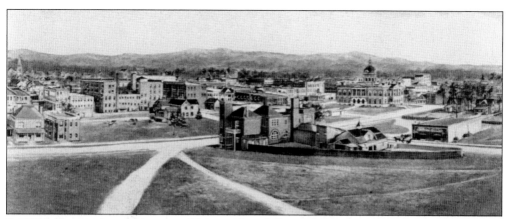

By 1900, Gurnee Avenue between Thirteenth and Eleventh Streets was the heart of the county and city government. The city jail and the warden's home, far left, were located just across the way from the municipal building. The city municipal building housed the fire and police departments, as well as all other offices of the city. Behind the municipal building were the city stables. One block south was the Calhoun County Courthouse. Noble Street, in the background, had grown from a residential area into a thriving downtown where businesses reached from approximately the 800 block to the 1400 block of Noble.

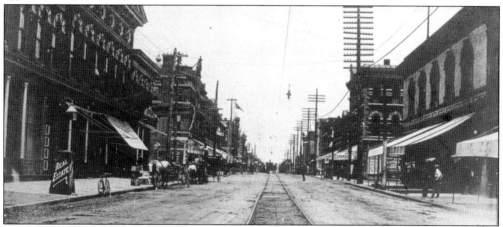

Noble Street, around 1888, had several large Victorian buildings anchoring the major city blocks. The intersection of Tenth and Noble, shown above, was dominated by the Noble Theater at the southwest corner, the Constantine Building on the northwest corner, Ullman Brothers at the southeast corner, and the Caldwell Building on the northeast corner. The Caldwell Building was the original site of the first school and Episcopal church in Anniston. The lot was sold in 1883 to William Howard Williams. A three-story brick building named after John Caldwell was erected on the site about 1890. Some of the early tenants were law and architectural offices as well as various dry goods stores. By 1898, Kohn Brothers operated a dry goods, shoe, and fancy goods store. Kohn Brothers closed up shop at 1001 Noble Street around 1908 and John W. Fore moved in his ladies' ready-to-wear garments, shoes, and furnishings store. A few years later, Rudolph Hertz's The Globe Clothing Store occupied the building. Around 1931, Mangel's department store for women occupied the Caldwell Building. During the 1950s, United Woolen Stores, Inc., a men's store, shared the building with Mangel's. When Mangel's closed in 1980, the building sat vacant for years. Helen Pugh Interiors occupied the building from 1994 until 1998. The building has since undergone restoration and is the current home of Noble Place.

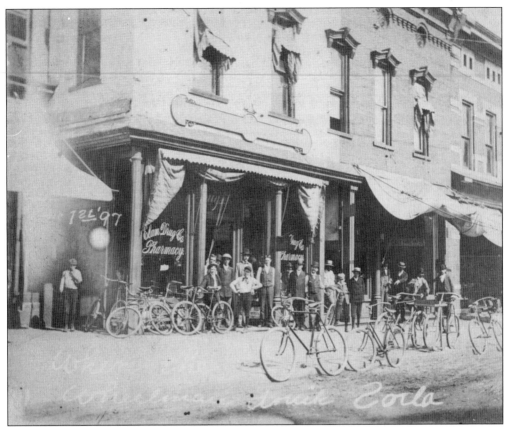

Elam Drugs was established in July 1894 by Edward E. Elam, who located his business at 923 Noble Street. It stocked drugs, paints, oils, glass, and other items. By 1900, Elam had moved the store to 1023 Noble Street. Wade H. Elam was in charge of the company by 1908, when the it was known as Elam, Ordway and House Drugs, and was located at 1025 Noble Street. In 1913, R.A. Hamrick was in charge of the store. Known as Elam-Hamrick Drugs, it was billed as a retail druggist, a prescription specialist, and an agent for Norris Candies, Waterman's fountain pens, and Dike's Household Remedies. In addition to these notions, the store had a soda fountain that sold mainly ice cream and colas. The drug store eventually became known as the Palace Drugs.

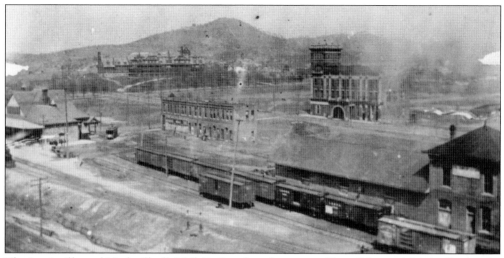

The Louisville and Nashville (L&N) Railroad made stops in New Orleans, Mobile, Pensacola, Montgomery, Talladega, Birmingham, Gadsden, and Anniston, among others. The tracks in Anniston were laid around 1889 when the L&N became the handler of the majority of iron in Alabama. Their tracks led directly into the Woodstock Iron Company, which caused problems with other rails in the city. The L&N freight office was located at Twelfth Street and Walnut Avenue and handled passengers until the Union Depot was built in 1895. The company also installed shops that were moved to Birmingham after the roundhouse burned in 1920. The L&N did retain a small shop at the yards northwest of the city in the 1950s. This freight office was renovated by Julian Jenkins in the 1990s to house his architecture firm and a restaurant.

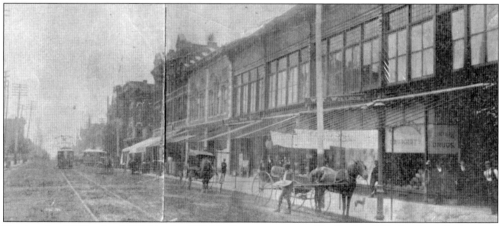

During the 1890s, the 1100 block of Noble Street grew rapidly. Richard H. Stickney Jr. located his drug store at 1116 Noble Street (far right). By 1898, he had moved the drugstore further down the street to 1124 Noble Street. To the left of Stickney's Drugstore at 1112–1114 Noble Street was W.T. Wilson's store, which sold dry goods, millinery, and house furnishings, among other things. The store did not last long and closed in the late 1890s. Max F. Doering was a jeweler and optician who had been in Anniston since the 1880s. He located his jewelry store at 1110 Noble Street and by 1896 shared the building with Samuel Robinson, who operated Robinson's Book Store. In addition to selling books, papers, stationary, and artists materials, Robinson's Book Store was also the library repository until 1917. Further down the block was the McKleroy Building, which was named for John McKleroy. The building was constructed in the 1880s and housed the Anniston National Bank among other businesses.

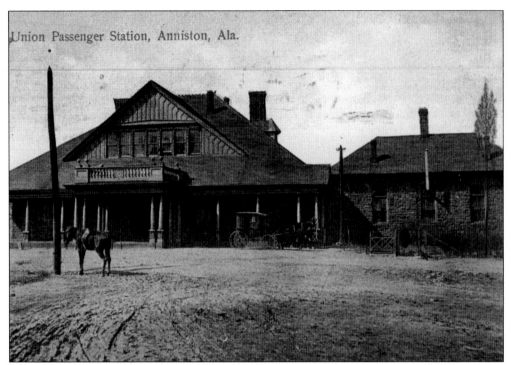

Union Passenger Station, Anniston, Ala.

The Union Depot was built for passengers in 1895 at 1300 Walnut Avenue. The station was also known as the Louisville and Nashville (L&N) station. Until 1926, the L&N shared the depot with the Southern Railroad. In 1948, due to a decline in passengers coupled with a coal strike, the L&N dropped passenger service to Anniston and never resumed it again, even after the strike was settled. The company leased the lower floor of the depot, but kept the upper floor for its offices. For many years, the depot was home to Kelly Supply. When Kelly Supply closed in 1992, the building sat vacant until 1999, when restoration work was started.

Three

DOWNTOWN

In the 1870s, the downtown area of Anniston encompassed only the 900 through 1100 blocks of Noble Street, and the company controlled almost every aspect of the town. The intersection of Tenth and Noble Streets was the main intersection in town. The Woodstock Iron Company had a boardinghouse, originally an old farmhouse, located near the intersection. The Selma, Rome, & Dalton Railway depot was at the foot of Tenth Street. The rest of Noble Street consisted of a mill, a company store, a church and school building, a drug store, a bake shop, a blacksmith shop, a few residences and farms, and a spring that was a gathering place for the town. Noble Street was then known as the Jacksonville Road. The road was not a straight line and wagons had to ford Snow's Creek at Thirteenth Street while pedestrians crossed on a foot log. The justice of the peace was housed next to Dr. J.L. Wikle's drug store on Noble Street. There was a public well, known as "the plug," located between the mill and Wikle Drug. The only professional men in the town were Dr. Wikle and Dr. R.P. Huger, the company physician. Lawyers, doctors, and other professional people did not arrive until after the town was opened to the public in 1883.

The town built an opera house in 1881 and a resort inn in 1885. In the 1880s and early 1890s, numerous banks were organized and located downtown. The downtown area expanded to the 1300 block of Noble. Among the merchants opening shops on the street were the Ullmans, Berman, and Saks. Business also developed west of Noble Street on Tenth and Eleventh Streets.

Trolley cars were a popular means of public transportation. They were generally horse drawn and followed along tracks laid in the center of the road. The horsecars ran on Noble Street from approximately Ninth Street to Thirteenth Street, which was the business district, and then turned west on Thirteenth Street to the Union Depot. From there, they made one last turn to go by the Anniston Inn.

During World War I, the newly established Camp McClellan, just north of Anniston, brought in numerous men to train, and as a result of this influx the town renovated the Anniston Inn. The soldiers lined the streets and spent their pay in Anniston businesses. There were few covered automobiles, so wagons were still a common sight along with street railway trolleys. The intersections of streets did not have traffic lights—rather, a police officer stood at every corner and directed traffic.

Much had changed by the time of World War II. The trolley cars were replaced by buses and hundreds of automobiles, many of which were military cars. By 1943, the temporary population of Anniston was 68,000 due mostly to the war work at Anniston Ordinance Depot and Camp McClellan. Post-war commercialism in the 1950s allowed families to own a car and move away from the city to the suburban areas at the edge of the city limits. This started the decay of the bustling Noble Street.

By the 1960s and 1970s Quintard Avenue became the main thoroughfare of Anniston. Businesses relocated from Noble Street to accommodate the population shift. The late 1980s and 1990s saw a revitalization of downtown take place. Many of the historic buildings were restored and occupied by businesses. However, it is doubtful that Noble Street will ever be the thriving street it was in the early days.

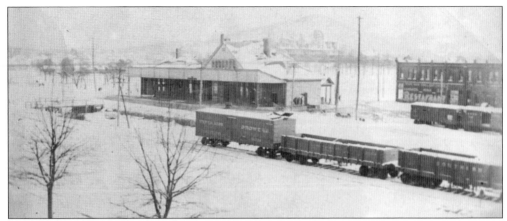

A restaurant was built at 228 West Thirteenth Street near the Union Depot. In 1896, J.M. Canfield operated it as the Georgia Restaurant. Two years later, the restaurant was under new management and a new name, the New England House Restaurant. It was managed by Peter A. Swanberg and his wife. Around 1905, Owen Daniels took over as proprietor of the New England House, followed by Mrs. Mamie Steinberg around 1913. The building changed hands again about 1917. Proprietors Triantis and Pappas operated the Union Hotel and Restaurant in the building. The Union Hotel had nicely furnished rooms at reasonable rates and a first-class restaurant that served meals at all hours, in addition to fruit confectionary, cigars, tobacco, and soft drinks. By 1922, the name had changed to the Royal Hotel. The building went through numerous owners and name changes throughout the years and was last used in the 1980s as a rooming hotel.

Anniston has had numerous banks throughout its history, but some did not survive. In April 1887, the Anniston Savings Bank and Safety Deposit Co. was organized with a capital of $50,000. At about the same time, the Bank of Anniston was organized by J.M., J.H., and G.W. Ledbetter with J.R. Draper as president. They owned the building at 1005 Noble Street and operated the bank until 1898, when it failed. J.C. Weatherly, Miller Sproull, and others established Anniston Federal Savings and Loan in 1953 on Noble Street. In 1961, the bank moved to 910 Quintard Avenue, where it remained until its closing in the 1990s. Another bank that had a brief life was Guaranty Federal Savings and Loan founded by H.R. Burnham and Thomas McKay in July 1969. The bank was closed by the 1980s.

Anniston National Bank was founded in 1890 by Capt. John McKleroy, Sam Woods, and Associates of Savannah. It operated at 1101 Noble Street in the McKleroy Building, which was built in the 1880s. Sam Woods was the first bank president. Anniston National merged with City National Bank in 1911. In 1954, the bank moved to the northwest corner of Twelfth and Noble Streets, and then to 1031 Quintard Avenue in 1958.

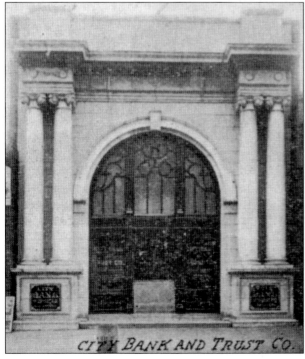

City National Bank was located at 1029 Noble Street and was organized in November 1901. In 1911, City National merged with Anniston National to form the Anniston City National Bank. James Keith was president of both institutions. A new bank building was constructed in 1954 at Twelfth and Noble Streets. The bank's present structure was built at 1031 Quintard Avenue in 1958. In 1982, Anniston National merged with First Alabama Bankshares. In the 1990s the bank was taken over by Regions Bank. (Courtesy of *Anniston and Calhoun County, Alabama*.)

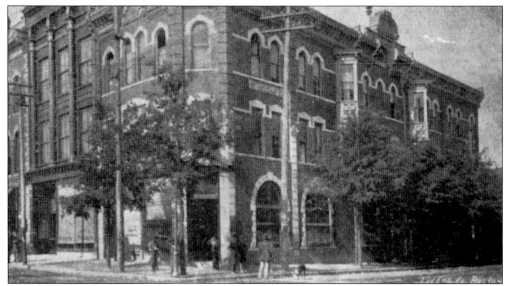

The Security Bank building was built by the Southwestern Land Company. The land company was organized on March 31, 1890, by J.J. Willett, Craig Cofield, and M.F. McCarthy. The bank building was constructed on the southwest corner of Eleventh and Noble Streets. The Security Bank of Alabama was established with a capital stock of $100,000. The bank failed to flourish and did not survive the Panic of 1893, so it folded. In 1896, Lloyd's Drug Store was housed in this building. J.J. Willett moved his law office back to the second floor of the building in 1908, where it remained until his death in 1955. W.E. Lloyd's drug store was renamed the Security Drug Store in 1940. The building was remodeled in 1953 and was used by various tenants. In the 1990s, the structure was restored to its original Victorian appearance. It currently houses Powell, Hancock, and Smothers Inc., as well as offices on the upper floors.

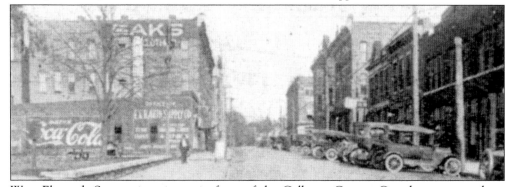

West Eleventh Street, since it ran in front of the Calhoun County Courthouse, was a busy area during the early 20th century. Joseph Saks, a native of Oberelsbach Bavaria, Germany, had come to America as a youth. Saks operated his department store, The Famous, in the Constantine Building, but in 1898 he moved it to the corner of Eleventh and Noble Streets. The name of the store was changed to Saks Clothing Company (left, c. 1920) and operated as a general department store. Saks also operated an 800-acre farm just north of town. The families that lived and worked on the farm were in need of a school for their children, so in the 1920s Saks donated the money to construct a school on the land. The Saks community grew out of this early farm. Other businesses located on the West Eleventh Street were Comer and Co., the Anniston City Land Co., the Nonnenmacher Building, and the Southeastern Express Company (all on the right). (Courtesy of *Anniston and Calhoun County, Alabama*.)

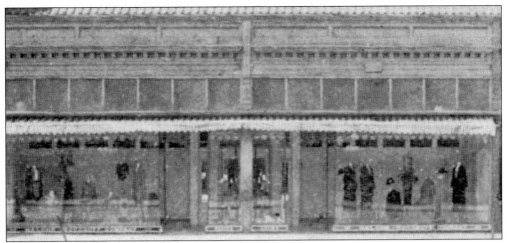

In 1900, Jacob Berman, an immigrant from Lithuana, established a shop between Twelfth and Thirteenth Streets on Noble Street. He sold dependable goods under the motto "Keep the customer satisfied." The shop grew rapidly and moved to 1112 Noble Street by 1938. In November 1961, the building burned along with two adjoining buildings. The following September, Berman's reopened in a modern building under the name New Berman's with a new owner, Sam Routman. New Berman's specialized in women's fashions. Routman also owned Gayle's, a department store he founded in February 1940 at 1128 Noble Street. In 1974, Routman moved Gayle's to 1116 Noble, closer to New Berman's. In the 1980s, the stores merged under the name Berman-Gayle's, which still operates. (Courtesy of *Anniston and Calhoun County, Alabama*.)

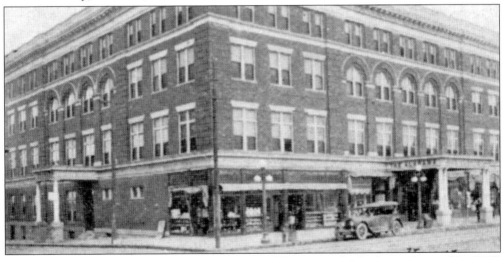

William H. Zinn was a key figure in building the Alabama Hotel, which was designed by C.W. Carlton and Company and constructed at a cost of $100,000 in 1902. The hotel was originally going to be named The Anniston, and sat prominently on a 130-foot frontage at the corner of Twelfth and Noble Streets. The main entrance faced Noble Street, while a ladies' entrance was located on Twelfth Street. The 4-story hotel had 94 rooms and 2 hydraulic elevators. In 1902, the builders promised a telephone in every room with long distance connections, sanitary plumbing, and private baths in 40 of the rooms. The first proprietors of the Alabama were F.B. Stubbs and George L. Keen. Rates ranged from $2.50 to $4 per day, depending on the type accommodations. (Courtesy of *Anniston and Calhoun County, Alabama*.)

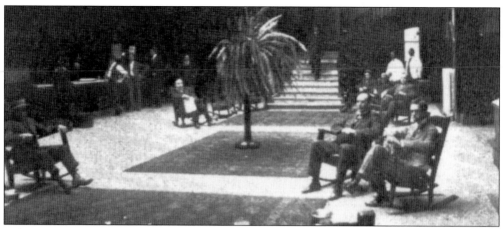

In his last years, the Alabama Hotel was home to Dr. J.L. Wikle, who could usually be found sitting in the lobby. A few years after Dr. Wikle's death, on September 15, 1944, a fire started in the Gem Beauty Shoppe in the Alabama Hotel. The hotel was also home to Nixon Transfer and Baggage Company, the chamber of commerce, the Alabama Drug Company, the Anniston Jewelry Company, the Southern Railway Ticket Office, and the Alabama Barber Shop. The hotel had 200 guests at the time of fire, but only two deaths occurred—a 70-year-old man and a soldier's young wife. It was one of the worst fires in the history of Anniston, causing approximately $200,000 in damages. (Courtesy of *Select Views of Anniston*.)

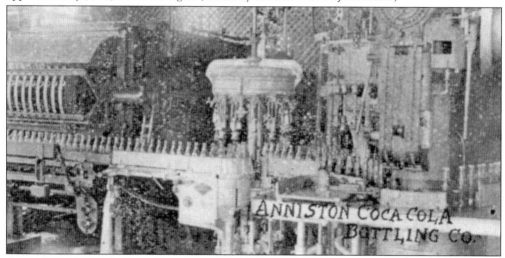

Around 1905, Frank W. Ledbetter organized the Ledbetter Bottling Works at Twelfth and Moore Avenue. In 1907, the Alabama Coca-Cola Bottling Company was chartered with Charles V. Rainwater as president. Coca-Cola dated back to the 1880s as a headache tonic. When Asa Chandler of Atlanta bought the formula in 1887 he began bottling and exporting the drink, and Coca-Cola became a national phenomena. The Alabama Coca-Cola Company purchased the Ledbetter Bottling Works in 1907 to use as a base for Coca-Cola bottling in the Anniston area. When the Alabama Coca-Cola Company expanded in 1909, the Anniston plant moved to 1010 Gurnee Avenue. The company bottled Coca-Cola, soda water, mineral water, and ginger ale. In 1931, the Coca-Cola company moved to 412–422 Noble Street, where it remained until 1976. In 1976, the Coca-Cola Company built a modern facility on Highway 78 in Oxford. The Salvation Army occupied the old Cola-Cola building in 1977. (Courtesy of *Anniston and Calhoun County, Alabama*.)

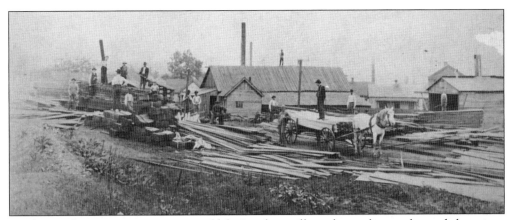

Lumber yards were a necessary part of life. Lumber mills took tree logs and sawed them into rough lumber, which was then sized by the planing mill until the lumber was smooth and between 8 to 20 feet in length. It was then cut into the needed sizes and dried in a kiln. Once dried, the lumber was stored in bins until sold. The lumber for household items, like cabinets and doors, was taken to a sash mill and made into the products. Among the numerous lumber yards and mills in Anniston was Lynch Lumber Yard at Ninth Street and Gurnee Avenue (shown above). The company was started around 1905 by Herschel Lynch, who had worked for Houser and Swain Lumber in the 1890s, and J.G. Adams. The company sold rough and dressed lumber, as well as building materials. By 1913, the company was a planing and lumber mill. Lynch Lumber had closed by 1924. Other lumber companies in Anniston around the same time were R.L. Perkins and Company at 920 West Tenth Street and the Dishman Lumber Company at 500 West Twenty-third Street. Some of the lumber companies dealt only in the retail portion of the business, while others had the capabilities of an on-site lumber mill.

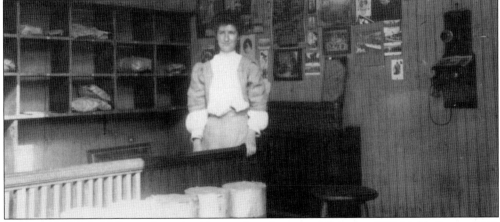

Around 1905, Model Steam Laundry (shown above) was established at 1201 Noble Street. C.H. Allen was the proprietor of the laundry until about 1922 when R.C. Gibson took over as the manger. The laundry billed itself as "The Place of Real Service. All classes of Laundering and dry cleaning." In 1926, Mrs. L.C. Gibson moved the laundry to 800 Noble Street. The laundry remained there and was owned by the Mallory family until the late 1940s. Another laundry in Anniston was the Anniston Steam Laundry, which was established by G.F. Wilson and W.A. Rose at Twelfth and Noble Streets in 1897. They bought out Empire Laundry in 1903. The business expanded and the laundry kept several wagons to collect and deliver its patrons' goods. The laundry moved around 1912 to 1213 Noble Street. Then, in 1938, it moved to Thirteenth and Gurnee Avenue.

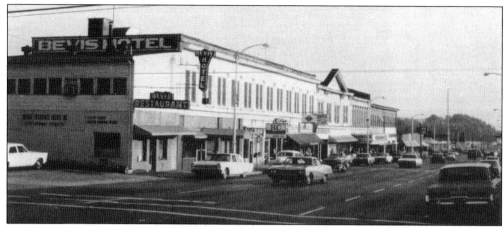

In 1905, the American House Hotel was built at 827 Noble Street. The hotel advertised that its rooms were equipped with steam heat, electric lights, and hot and cold water. By 1912, D.E. Evans was the proprietor of the hotel and began refurbishing the structure. Room rates ranged from 50¢ to 75¢ and meals were 25¢. Patrons could purchase a room and a meal plan for $1.50 per day. Mary Cashman was the proprietor in 1917 and the name became simply the American Hotel. By 1935, Luther Bevis had acquired the hotel and changed the name to the Bevis Hotel. The old Bevis hotel and businesses located on the first floor burned in 1987. Today, the site is the parking lot for the Williamson Commerce Building.

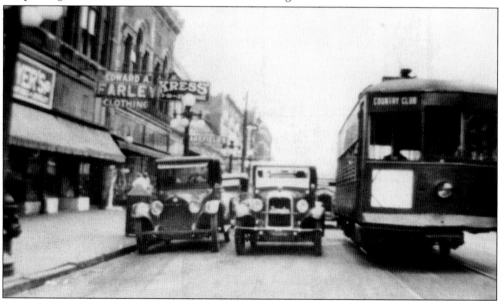

Samuel H. Kress began his 5&10¢ company in 1896. He provided customers with quality merchandise at the lowest possible price, a practice that eventually became synonymous with S.H. Kress and Company. On November 25, 1905, the S.H. Kress and Company's 5, 10, & 25¢ store opened at 1108 Noble Street (shown at left). The store was remodeled during the 1930s and took in the small building to the north at 1110 Noble. Kress Company architects were responsible for designing interiors, exteriors, and renovations. The remodeled and enlarged Kress store occupied 1106 to 1110 Noble Street. In 1964, Genesco, Inc. took over the Kress Company and by 1980 they were closing stores and liquidating the business. The Kress store in Anniston closed around 1981.

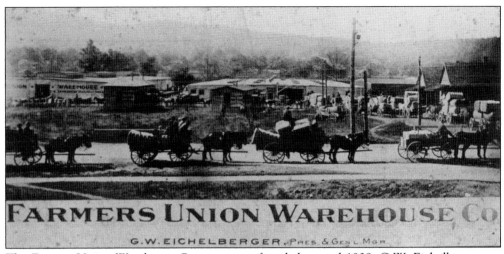

FARMERS UNION WAREHOUSE CO.

G.W. EICHELBERGER, Pres. & Gen'l Mgr.

The Farmers Union Warehouse Company was founded around 1908. G.W. Eichelberger was president and general manger of the warehouse that was located on West Sixth and Powell Streets at the Southern Railroad. The building was constructed with concrete throughout and reinforced with steel. In addition to the sturdy materials used, it was equipped with automatic sprinklers, and it was promoted as being the only absolute fire-proof cotton warehouse in northeast Alabama. It closed its doors in 1981 under the management of Robert Sherer.

Furniture stores in Anniston were numerous. In 1908, the Allison and Paschal Furniture Store was located at 809 Noble Street in the Kaplan Building, which was constructed in 1905. James Allison was the proprietor of the store, and by 1913 Cliff Allison had joined the company. In 1922, the store expanded to take in the building next door. Warnock Furniture moved from 100 West Thirteenth Street into the building vacated by Paschal and Allison in 1929. Warnock's was originally opened in 1880 by R.N. Warnock in Oxford. The store sold furniture, dry goods, clothing, hardware, and groceries. Around 1900, when W.C. Warnock ran the store, furniture became the dominate line of stock. R.P. Warnock Sr. joined the firm in 1912 and three years later the store moved to Tenth Street and Gurnee Avenue in Anniston. The store on West Thirteenth Street, where the family lived above it, was not occupied until around 1922. In 1929, the store moved to the 809 Noble Street location where it remained until 1985. The Kaplan Building burned along with the Bevis Hotel in 1987.

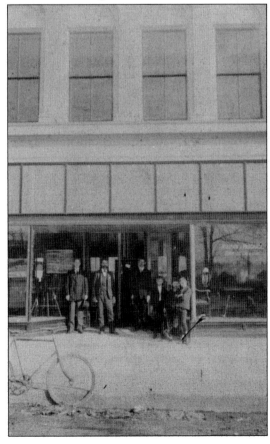

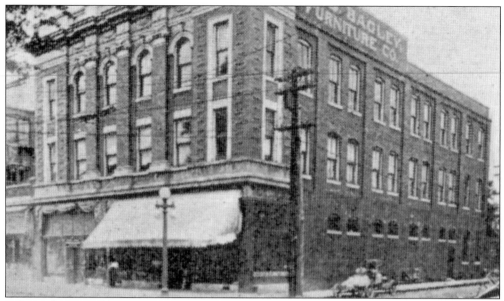

T.S. Bagley started his furniture and undertaking company around 1907 at 13–15 East Tenth Street. By 1917, he had taken on a partner, Albert Stanley. George Cater purchased the furniture business in that same year. The undertaking portion of the business was taken over by Stanley & White around 1924. Cater kept the furniture business until 1965, when Rhodes Furniture took over the building. In 1988 Rhodes closed and the building was renovated. Couch's Jewelers moved to the building in 1990. Couch's was not a new business; it was started in 1897 by the Russell Brothers, who had a photography studio and gift shop on the second floor of Wikle Drug. In 1943, Fred and Frances Couch purchased the business, which operated on Noble Street until 1990. The Couch's three sons continue to operate the family business at 15 East Tenth Street. (Courtesy of *Anniston and Calhoun County, Alabama*.)

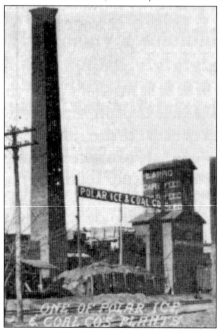

Before the introduction of electric refrigeration, ice men were important figures in towns. People used snow and ice to preserve and cool food. The ice business started in the 1800s when ice blocks were cut from lakes, generally in New England, in the winter and then stored in icehouses to be shipped across the United States. Anniston's Polar Ice and Coal Co. was founded around 1914 with J.W. Mallory as president. It was located at 1406 Glen Addie Avenue. The ice blocks were packed in sawdust to keep them from melting and then placed on a delivery wagon. Once the delivery man carried the ice blocks inside, the blocks were stored in insulated iceboxes. The introduction of the electric refrigerator in 1916 started the downfall of the ice companies. By 1929 the Polar Ice Company closed, due mostly to the wide spread use of the refrigerators. (Courtesy of *Anniston and Calhoun County, Alabama*.)

Around 1917, the old Elam Drug Store became the Palace Drug Store under the guidance of J.H. Witherspoon. The drug store remained at 1025 Noble Street until it closed in 1952. Sunlite Electrik Bake Shop began operating at 1119 Noble Street around 1929 with J.W. Baber as the proprietor. By 1935, the bakery had moved to 1130 Noble Street and was operating under the name Electrik Maid Bake Shop. The store had several managers from 1935 until 1944. Around 1942 the bakery moved next door to the Palace Drug Store, at 1023 Noble Street. In 1944, George Alsmiller bought the bakery and operated it until it closed in 1988.

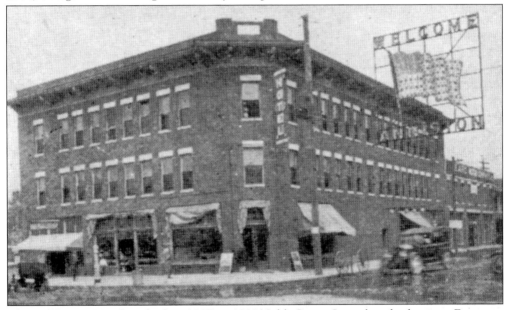

The Manhattan Hotel was built in 1917 on 1301 Noble Street. It was listed as having a European plan, which meant meals and a room were priced together. J.C. Stiles managed the hotel for several years. Around 1926, the three-story brick hotel's name was changed to the Jefferson Davis. An addition was made to the original structure in 1942. From 1966 to about 1977 it was known as the American Host Inn Hotel, and in 1978 it became the Heart of Anniston Inn. (Courtesy of *Anniston and Calhoun County, Alabama*.)

Prior to the Civil War very few people were embalmed when they passed away. Funerals often took place in homes or churches. During the Civil War undertakers followed the Union troops into battle, so that the soldiers' embalmed remains could be sent home to the family. Many undertakers, as well as ambulances, were based in furniture stores. Eventually undertaking businesses separated from furniture businesses and funeral parlors became the norm. As early as 1917, J. Ralph Usrey worked in the Anniston undertaking business, as the undertaker for Louis Kidd. By 1922, Usrey partnered with T. Lee Smith to form Smith and Usrey Undertaking. The Usrey Funeral Home was established in 1924 at 1407 Noble Street, with T. Flint Gray in charge. By 1942, the funeral home moved to 1329 Wilmer (shown above). Owner T. Flint Gray changed the name to Gray-Brown in 1960.

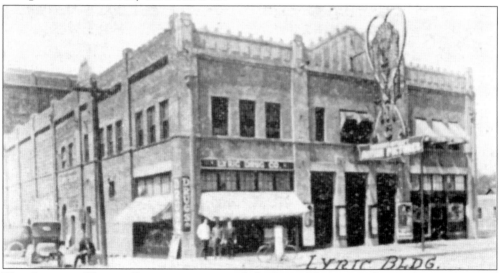

The Anniston Theatre Company constructed the Lyric Theatre at the northwest corner of Thirteenth and Noble in 1918. In 1919, the theatre company sold the building to the Anniston Amusement Company. From 1918 to 1928 the Lyric was host to the main circuit of Keith Vaudeville from New York and a summer chautauqua circuit, a program of adult education that brought culture to remote areas. The building was sold in 1924 to F.T. and E.D. Banks. By 1928, the building was leased and slightly remodeled by Publix, a major motion-picture theater chain, and the name was changed to the Ritz. In the early 1930s, a subsidiary of Paramount Pictures leased the building. The Anniston Little Theatre purchased the building in 1975. The Ritz was abandoned in 1980. In the 1990s, the building was adapted and reused as an office complex, after sitting vacant for many years. (Courtesy of *Anniston and Calhoun County, Alabama*.)

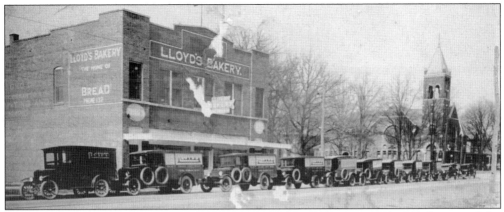

Shortly after Ernest C. Lloyd purchased Nonnenmacher's Bakery around 1919, he moved the bakery to 1207 Noble Street. Lloyd, a baker from Rome, GA, was inventive with his advertising by using his own sky-writing airplane liberally to advertise his business. The bakery was billed as "the home of the golden crust bread." Lloyd's Bakery quickly outgrew the shop and by 1924 it moved to 1316 Noble Street. The bakery did expand throughout the years, but closed in 1952. Around 1955, Lloyd tried a new business venture at the bakery location. Lloyd's Cafeteria and Bakery was a modern cafeteria that had freshly baked goods and specialized in wedding and birthday cakes. Lloyd billed it as "Anniston's only Cafeteria and Home Bakery." By 1957, the cafeteria was owned by J.W. Gardner, who moved it briefly to West Thirteenth Street. Gardner operated Gardner's Cafeteria, Bakery, & Grill at 1316 Noble Street from 1960 until 1975.

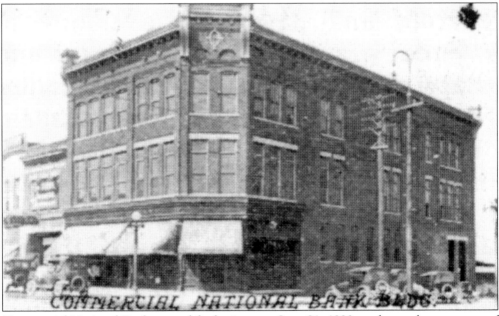

Commercial National Bank opened for business on June 21, 1920, at the southwest corner of Twelfth and Noble Streets with a starting capital of $300,000. C.R. Bell was the first president and chairman of the board. On December 25, 1945, a fire destroyed the bank building, so temporary quarters were set up on Twelfth and Court Streets. Commercial National Bank moved into the ten-story Liles-Wilson Building on April 11, 1947. In 1973, the bank became part of the Alabama Bancorporations, which eventually incorporated into AMSouth Bank. (Courtesy of *Anniston and Calhoun County, Alabama*.)

In 1922, John B. LeGarde was the president of the Dairymen's Milk Products Company. The surrounding area had several dairy farms since there was a large amount of grasses for the herds to graze on. Dairymen's Milk Products Co. was one of two creameries in Anniston. It sold all-milk products, chocolate milk, and pure ice cream, and was located at 127 East Tenth Street on the corner at Quintard Avenue. By 1926, the company had changed its name to the Dixie Ice Cream Company, with B.R. Sawyer as its president. Ten years later, it was operated as the Lily Pure Cream Company. In 1951 it was bought out by the Borden's Ice Cream Company. The location became a district office in the early 1960s, shortly before operations at it were closed. (Courtesy of *Anniston and Calhoun County, Alabama*.)

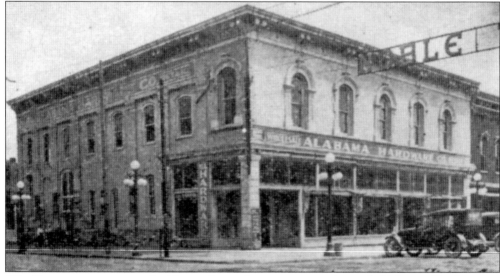

C.J. Houser, a prominent builder and merchant, was president of Alabama Hardware in 1922. The store was located at the corner of Tenth and Noble Streets, the site of the original Woodstock Commissary. The store billed itself as the Winchester Store and sold such things as hardware, mill supplies, sporting goods, cutlery, kitchen ware, farm implements, paints, and oils. The local hardware store was also where brides registered for their weddings in the early years. When the Liles Building was built on the site in 1926, the hardware store moved to 901 Noble Street. (Courtesy of *Anniston and Calhoun County, Alabama*.)

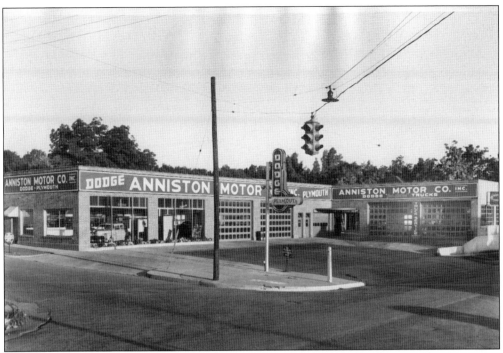

The Anniston Motor Company began selling cars around 1929. Under the general management of R.C. Gaines, the company sold Dodge and Plymouth motor cars and Dodge job-rated trucks. Around 1940, the car lot was moved to 101–107 West Tenth Street. The car lot stayed at that location until 1953, when it moved to 831 Wilmer (shown above). The dealership changed in 1962 to Tucker Oldsmobile Buick Incorporated. Eventually car lots relocated to South Quintard after it opened in the late 1950s. In 1975, Clyde Kitchin built his Incredible Kitchin's department store on the lot. The clothing store was started in 1951 on Noble Street and was one of the first stores to provide a parking lot. Eventually the name of the clothing store was changed to simply Kitchin's.

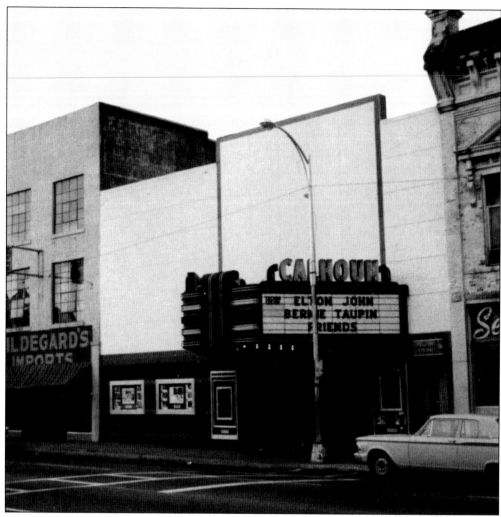

The Calhoun Theater was built in 1942 at 1220 Noble Street. Tom Coleman Sr. served as manager of the Calhoun until 1952, when H.T. Stafford was named the manager. He remained at the post until he retired in April 1972. In 1960, The Calhoun became part of ABC Southeastern Theaters Inc., a subsidiary of the American Broadcasting Company (ABC). The theater limped along until it closed around 1983, because it was unable to compete with the large chain movie houses.

Four

MUNICIPAL

In 1872, the town government was under the complete control of the Woodstock Iron Company. During the July 12, 1873 election, the town of Anniston was incorporated with 46 votes favoring and only 2 opposed to incorporation. In December 1873, Charles J. O'Rourke, the superintendent of furnace operations at Woodstock Iron, was elected intendant (mayor) under the town charter. It operated under this charter until 1879.

In February 1879, Anniston was granted a charter by the state of Alabama under an intendant-council form of government. The governing body of Anniston was the councilmen, council president, and the mayor. In 1928, the mayor went back to serving one-year terms. The mayor-council form was retained until 1939, when the city commissions form of government consisting of six wards was established. This form remained until 1968, when a vote was held to change to a council-manager plan, which continues to the present.

The city government changed along with the times in the late 1960s. In 1969, African-Americans received appointments to major municipal boards as well as being elected to the city council. In 1976, Anniston elected its first female council member, Gertrude Williams. When the mayor resigned in 1979, Ms. Williams assumed the office. In 1980, she was elected outright.

Anniston's growth was so rapid in such a short time that it rivaled Jacksonville for the county seat. The first issue of the removal of the county seat from Jacksonville to Anniston came from an 1883 article in *The Hot Blast* by editor Charles Howard Williams. The county government answered the charges of Anniston by building a new courthouse. When Emmett F. Crook won the probate judge's race in 1886, he was in favor of keeping the courthouse in Jacksonville. The issue subsided but resurfaced again in 1898. Dr. T.W. Ayers, editor of *The Jacksonville Republican*, favored the move and conducted a survey that showed 65% of the county's population lived closer to Anniston. Other Annistonians joined the fight.

In 1899, the Alabama State Legislature passed a bill to hold an election for the Calhoun County seat. The ballot tickets were printed on colored paper, to allow those who could not read to vote. The official vote was 3,840 for Anniston to 2,236 for Jacksonville. A few days after the election, Anniston was officially certified as the county seat. A court order was eventually issued based on the claim that the act that authorized the county seat election was unconstitutional because the voting secrecy requirements were not enforced during the election. The case was appealed to the Supreme Court of Alabama, where it was turned down in June 1899. The county offices found a temporary home in the Anniston City Land Company building until the courthouse was completed in 1900.

On February 21, 1901, the Alabama House passed a consolidation bill which made Oxanna part of Anniston. Oxanna was opened to the public in December 1883 and lots were sold by the Oxanna Land Company. The small town had a post office manned by F.E. Gailbrath, Joseph Shaffield's Oxanna Hotel, a hack line operated by Z.E. Taylor, and an agent for the Georgia Pacific Railroad. B.F. Sawyer was the editor of *The Oxanna Tribune*. The little town stretched south on Quintard at Hot Shot curve and was built up by the foundries and mills. Eventually churches opened on lots donated by the Oxanna Land Company. Once Oxanna became part of Anniston the Sixth Ward School was established for the children of Oxanna to attend.

The town water supply became a concern once the population started to grow around 1882. Originally the town used the streams and creeks of Choccolocco Valley to supply water. In 1882, the town constructed a water works. The water came from an encased artesian well on Twelfth Street and Moore Avenue, near the aqueduct that ran under the city. The water was piped to a reservoir on Tenth Street near Hillside Cemetery. The well was sunk 75 feet in the ground and measured 10 feet in diameter.

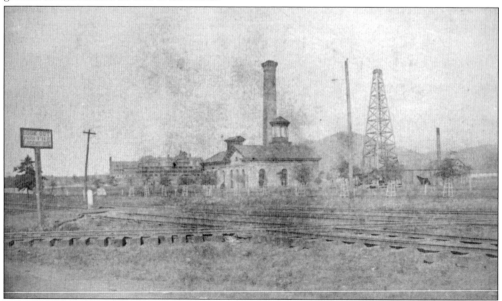

The town water works was located approximately 500 yards west of Noble Street. A heavy coat of iron rings lined the walls of the sunken well. The water was supplied through a 10-inch pipe with an 8-inch water pipe used to convey water from the main pipe to town. A 150-horse power steam engine forced the water into the reservoir on east Tenth Street. The water pressure was approximately 100 pounds per inch and the reservoir was almost always full. Heavy iron pipes were laid through the streets and over 40 fire hydrants were installed at different points throughout the city. The encased well was uncovered in 1927 and was later paved over when Moore Avenue was widened.

Coldwater Springs was named by early settlers because the water was very cold for the climate, approximately 58-degrees fahrenheit. In 1888, Samuel Noble purchased Coldwater Springs from Bartley Bynum. The 160-acre site was not developed until much later. When Samuel died in 1888, the ownership of the springs passed to his son, Stephen Noble, who sold the springs a short time later to Duncan Parker and T.G. Bush. In February 1889, Parker and Bush organized the Anniston Water Supply Company. The men had little capital stock so they enlisted the Lehman Brothers of New York to provide bonds for the water company. With $400,000 proceeds from the bonds, a pumping station was built at Coldwater. Pipes were laid from Coldwater Springs into Anniston, a distance of approximately 8 miles. All rights in and to the water works systems were purchased by the Anniston City Land Company. The city purchased the water works in 1935. (Courtesy of *Anniston and Calhoun County, Alabama.*)

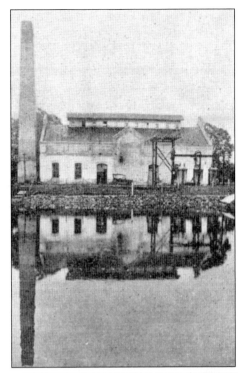

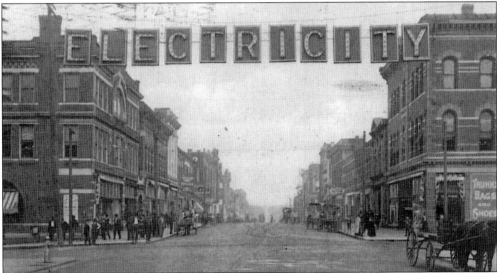

The Woodstock Iron Company constructed a system of electric lights in 1882. Globes were placed on masts and erected above the Anniston Manufacturing Company, the flour mill, Noble Street, Tenth Street, and in each of the two furnace sheds. Wires were then connected to the generator engine in furnace #2. In 1884, a contract was made with Brush Electric Company for a plant to light the town and furnaces by electricity. Anniston's "White Way" was lit in 1912 and it is believed to be the first white way system installed by a Southern city. Downtown merchants paid the initial costs of the installation of lights on Noble Street and the city agreed to furnish the electricity. The system was later taken over and expanded by the city. In 1951, the lights were replaced by mercury vapor lights.

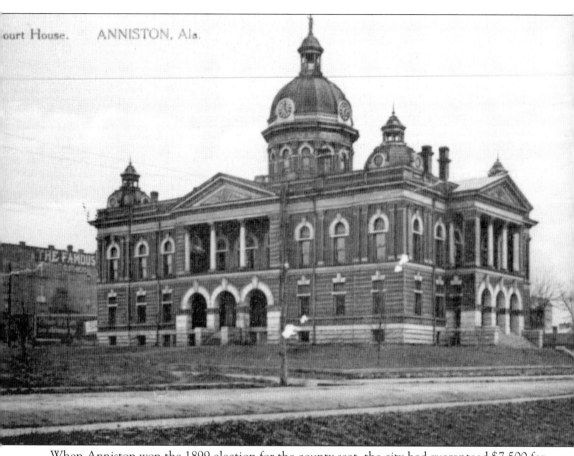

When Anniston won the 1899 election for the county seat, the city had guaranteed $7,500 for the cost of moving the existing courthouse building from Jacksonville, but this never occurred. Instead, a new $150,000 courthouse was built on the corner of Eleventh Street and Gurnee Avenue. A $100,000 bond was floated to raise money for the courthouse. Architects for the building were J.W. Gulucke and Company, with the construction contract awarded to S.C. Houser and Thomas Wolsoncroft. The cornerstone for the courthouse was laid November 15, 1900. The contractors left the job incomplete, so the bondsmen completed the building for about $30,000. In 1924, an annex to house the probate office and jail was added to the north side of the courthouse. A fire destroyed the building in January 1931 while thousands watched. There was approximately $110,000 of insurance on the building and $3,000 on the furnishings, but the estimated cost to replace everything was $200,000. It was eventually refurbished and a new, slightly-smaller clock tower replaced the cupola. In 1963, an unbecoming modern addition was attached to the southeast corner of the building. The courthouse was remodeled, paid for by a 3¢ tobacco tax, and unveiled to the public in October 1992.

On May 14, 1896, the Anniston Library Association was established with H.W. Sexton as president. The repository for the library was at Robinson's Book Store at 1032 Noble Street. Samuel Robinson was the owner of the store and the town librarian. Around 1898, Robinson moved his book store to 1110 Noble Street, where the Robinson Circulating Library remained until 1917. In 1910, the city received a piece of land through the will of Mr. R.E. Garner. With funds received from the (Andrew) Carnegie Foundation, construction began on the new library. The Carnegie Library was opened on May 24, 1918, at the corner of Tenth Street and Wilmer Avenue. By 1919, the library had 5,000 books and a circulation of 20,187.

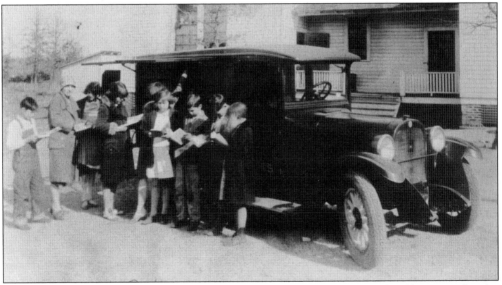

In November 1927, the first Calhoun County Library was founded. The library, under the leadership of Margarite Edwards, was a traveling library, whereby books were carried from different stations throughout the county. A truck to transport the collection was bought with money donated by individuals, and the state of Alabama contributed 1/3 toward book purchases. By 1931, there were 64 rural library stations and around 8,300 books in the collection. Eventually, the bookmobile was replaced with one that had a custom-built body and a larger capacity for books. This allowed the rural residents of the surrounding areas to have the same opportunity to obtain books as people in the city.

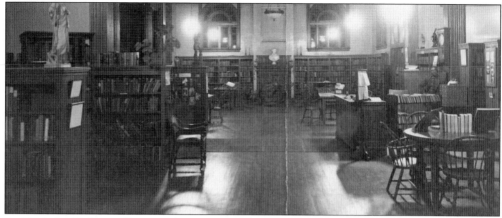

In 1964, the Calhoun County Library merged with the Carnegie Library (shown above) under the name of the Public Library of Anniston and Calhoun County. A new building, Liles Memorial Library, was built on the site of the Carnegie Library through a $150,000 bequest from the Luther B. Liles estate, along with federal funds. The building was dedicated in October 1966. The following year, the Alabama Room was created to house special collections and a special department was added to aid the disabled with services. In 1976, the Cheaha Regional Library began operating from the Liles Library building and served Calhoun, Cherokee, Clay, Cleburne, Randolph, and Talladega Counties, through individual libraries, as well as with bookmobile services.

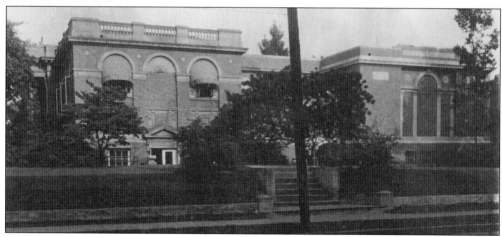

In 1929, H. Severn Regar gave his collection of two Egyptian mummies, mounted birds from the collection of 19th-century naturalist William Werner, and assorted historical artifacts to the city of Anniston. The city raised $3,500 to pay for the shipping and financed a bond-issue to pay for an addition to the Carnegie Library to exhibit Regar's collection. In August 1930 a two-story addition to the back of the library was completed. When the Carnegie Library was replaced in 1965, the collection was transferred to the Calhoun County War Memorial Building at 1407 Gurnee Avenue, the former Calhoun County Library. That same year the city council appointed the first Museum Board, which included John B. LaGarde and Farley Berman, to plan the future of the museum. A building fund was started in the mid-1970s and over $800,000 was raised. Construction on the Anniston Museum of Natural History started in January 1976 and was completed the same year. The Regar Collection was the foundation for the Anniston Museum of Natural History, which also includes the John B. LaGarde International Mammal Collection.

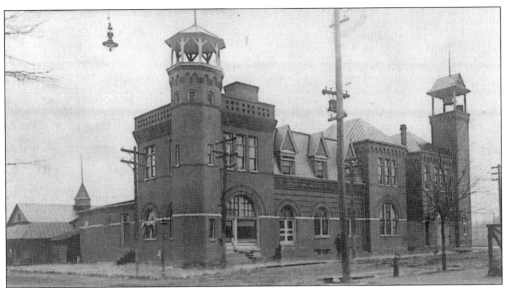

The original city hall was located in the 900 block of Noble Street until 1887, when the Anniston City Land Company offered to donate the corner lot at Twelfth Street and Gurnee Avenue for the city to construct a municipal building. In October 1887, a $13,275 contract was awarded to local contractors Badders and Britt. The municipal building was formally accepted by the city on August 7, 1888. It housed the mayor, city council, police and fire departments, and all other city functions. In December 1942, a fire in the basement heavily damaged the city commission offices, meeting room, court room, and other facilities. The damages were repaired and the building continued to be used. After World War II, the city acquired the USO building across the street and moved the mayor and city clerk there. Other offices followed and the municipal building was eventually given over to the police department.

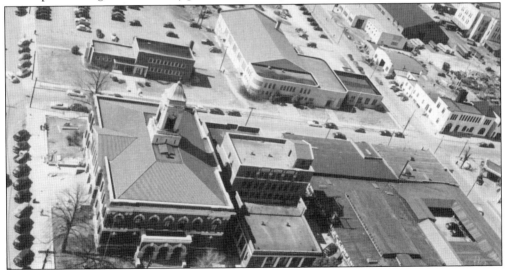

In 1955, the city hall was razed to make way for a new building on the same lot. By 1956, the new building housed the police department, city engineer, electrician, and building and plumbing inspector. All other city offices, along with a recreation hall, were quartered across the street in the former USO building. In 2000, the old recreation hall building was transformed into executive offices.

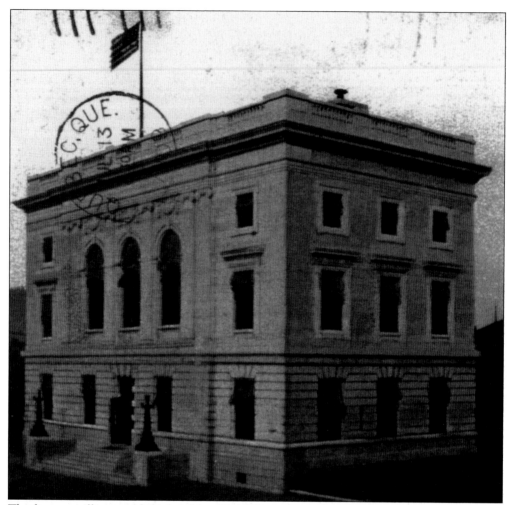

The first post office, established on May 13, 1873, was located in the Woodstock Iron Company Commissary. The postmaster was Capt. W.A. McMillian, the company storekeeper. In the 1880s, the post office moved to the northwest corner of Tenth Street and Quintard Avenue where it remained until the late 1890s, when it moved to 1031 Noble Street. In March 1899, Congress authorized the construction of a post office building, and appropriated $25,000 for construction to begin. A 130-by-120-foot lot at 1129 Noble Street was ceded by the state of Alabama to the federal government. Construction lasted from 1904 to 1906, and cost $153,000. In 1906, the white marble facing and brick building was occupied with Lansing T. Smith as postmaster. In the 1920s, a small workroom was built on the main floor. A major remodeling of the building in 1935 forced postal operations to move to the corner of Thirteenth and Noble Streets for two years while the work was completed. During the renovation the exterior was replaced by similar marble facing, a rear wing was added that included several offices on the second floor, the mail workroom was increased in size to provide a lounge for employees, and an elevator was installed to extend to the third floor. In the 1950s, the building housed the federal court, offices of the district judge and postal inspector, and the Alcohol and Tobacco Tax Unit. The building now houses the U.S. District Court, bankruptcy court, congressional offices, Department of Labor, Wage and Hour, and probation officers. The current post office, built in 1962, is in a modern facility on the corner of Eleventh Street and Quintard Avenue. (Courtesy of Mrs. T.E. Kilby Jr.)

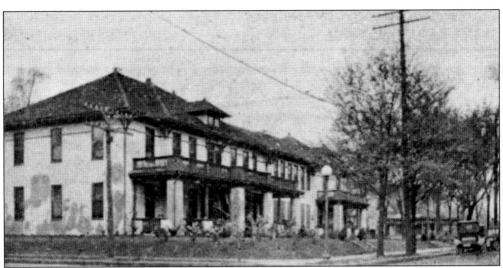

The Sellers Hospital at Fifth Street and Leighton Avenue was organized in 1907 by doctors E.M. and W.D. Sellers. The hospital had a 25-bed capacity and was limited to only a few doctors. In 1917, Dr. Neil Sellers bought the hospital from the brothers and two years later it burned. It was replaced by a 50-bed hospital in 1923. Sellers Hospital and its equipment were sold to the city on December 31, 1929. The city consolidated Sellers, St. Luke's, and St. Michael's Clinic into one city hospital, Garner Hospital. Garner opened in 1930, in the Sellers Hospital building, with 11 employees and 12 student nurses. By 1940, the hospital had 60 beds and 8 bassinets. The building currently houses Beckwood Manor Nursing Home. (Courtesy of *Anniston and Calhoun County, Alabama*.)

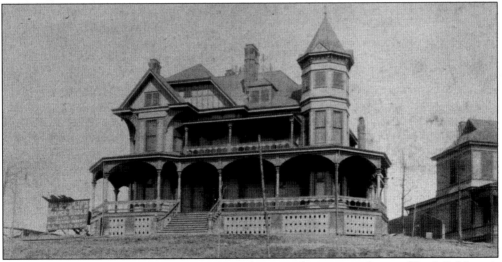

Around the turn of the 20th century, Oma Dickert was the nurse in charge of Dr. J.C. Moore's private clinic at 908 Quintard Avenue. She conferred with other town doctors about opening a hospital and they agreed to back her if she needed help. Ms. Dickert along with her assistant, Olga Landt, rented the Robert Riddle house (shown above) at the head of Gurnee Avenue on Marvin Hill and opened the Anniston Hospital around 1908. The two women trained girls to help with the nursing. The hospital remained at the house for approximately two years; the women then moved the hospital to Dr. Hiram Barr's house on Fourteenth Street and Leighton Avenue.

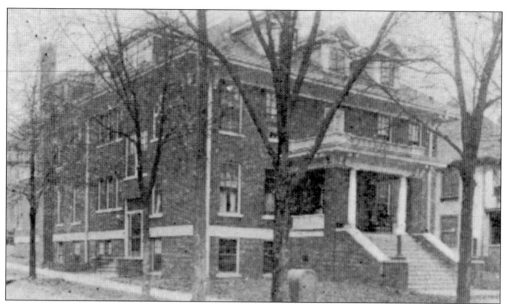

Around 1911, some of the doctors who practiced at the Anniston Hospital formed the St. Luke's Company, when a plan to merge the hospital with Sellers Hospital fell through. They bought the Anniston Hospital and renamed it St. Luke's. The company moved the hospital to the renovated Riddle House on Marvin Hill in 1912. In 1914, Dr. T.J. Brothers, Dr. Thomas F. Huey, Dr. A.N. Steele, Dr. J.C. Moore, Dr. R.L. Bowcock, Dr. H.A. Leyden, and Dr. I.P. Levi erected a 40-bed hospital at 1129 Quintard Avenue. Around 1929, St. Luke's was sold to the city. It was erected as a civic project that operated without profit. The stockholders in the St. Luke's Company received their original investment along with a very small amount of interest. St. Luke's was consolidated with St. Michael's Clinic and the Sellers Hospital to form Garner Hospital. (Courtesy of *Anniston and Calhoun County, Alabama*.)

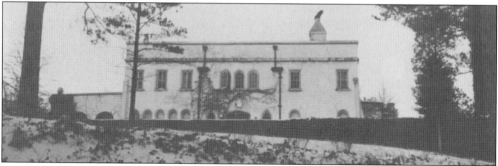

When Susie Parker Stringfellow died in 1920, her will outlined the use of her home upon the death of her husband. When W.W. Stringfellow died in 1932, the Italian villa-style home, the grounds, and two-thirds of the estate (approximately $200,000) went for the establishment and maintenance of a hospital. A board of trustees consisting of 13 Anniston residents and 2 representatives (a man and a woman) from the 5 leading churches was convened in 1937. The hospital was to be maintained for the public without gain or profit and be open to all reputable physicians. On August 1, 1937, the tuberculosis hospital opened with 10 beds. There were two large patient wards, several private rooms, an operating room, and clinic. African-American patients were cared for in a garage apartment once used as servant's quarters. Patients were admitted only if hospitalization would benefit the patient's condition. Surgery was rarely performed, so those needing operations were sent to Birmingham.

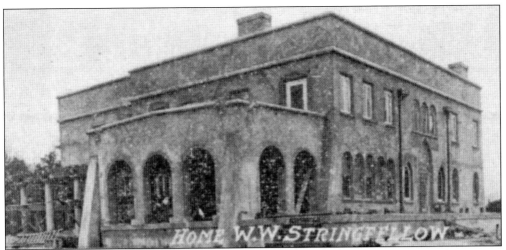

Stringfellow Hospital had a staff of four registered nurses, a cook, and a maid. Very little money was collected from patients for services rendered. In 1954, patients were removed because of the deteriorating conditions of the building. Three years later the 32-bed, $350,000 Stringfellow Memorial Hospital was financed. It was intended to relieve space in a general hospital, so a highly trained staff was employed. The hospital had two four-ward rooms, two private rooms, and eleven semi-private rooms. Each room, decorated with pastel colors, had a sliding glass door that enabled patients to roll onto the terrace. Billy N. Glass was hired as the administrator and patients were received starting in 1958. The hospital went through renovations in the 1980s and now includes an emergency room and operating room. (Courtesy of *Anniston and Calhoun County, Alabama.*)

Robert Garner and Louis Kaplan had set up funds to build a general hospital. Plans for Anniston Memorial started as early as 1940, but due to World War II and the lack of steel, the hospital was not built until 1943. The contract for construction was awarded to the McDougal Construction Company by the Federal Works Agency. Construction began in July 1943. On October 20, 1944, the first board of trustees of the new hospital met. The hospital opened with 100 adult beds, 5 children's beds, 24 bassinets, and a staff of 16. A pharmacy was installed at the hospital in 1951. A school to provide clinical training for student nurses was established in 1953. In January 1955, the hospital lost its accreditation and closed the school of nursing. The accreditation was returned in February 1957. A south tower was added in 1962, to increase the hospital capacity to 216 beds. In July 1969, at the suggestion of Dr. Warren Sarrell, an Intensive Care Unit was added at a cost of $100,000. In 1972, the hospital was made a regional hospital and ownership was moved from the city to a non-profit hospital authority. In 1974, the hospital's name was changed to Northeast Alabama Regional Medical Center. A new emergency department and surgical suite was added along with a north tower in 1978. Currently it is a fully accredited regional medical center that includes home health care, same day surgery, oncology, and women's health centers.

In the early days of Anniston a police force really was not necessary, since all were employed by Woodstock Iron and could be dismissed for any infraction. Anniston's police department dates back to 1872, when the city council appointed C.M. Fitzgerald the first city marshal. It was the marshal's job to collect taxes, inspect meat, and sweep out the market house after the close of the market each day. The job paid $1 a day and all expenses had to go through the city council. In 1878, the city provided officers with uniforms and the chief could feed his horse at the city's expense. Under the 1879 Town Charter, the marshal's job was to tend the jail, auction property when taxes were delinquent, make sure the town had adequate hitching posts, and ensure that horses were not hitched to shade trees. By 1882, the marshal's job paid $500 a year. The job description of the police in 1886 also included removing all dead trees on city streets and selling the wood for the city. When the Civil Code of 1890 was passed, it formally established a police department. The department was to be manned by a sergeant, two station keepers, two mounted officers, eight patrolmen, and a guard for the chain gang.

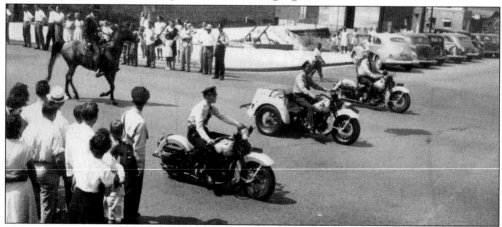

In the early 1930s, the Anniston Police Department consisted of 15 men. J.L. Peek was named chief of police in 1939, and under his guidance the police department expanded. The detective division was created in 1943 with T.A. Cannon acting as detective captain. In 1945 the police department employed about 33 uniformed officers and 6 detectives, and had 4 two-way radio police cars in operation.

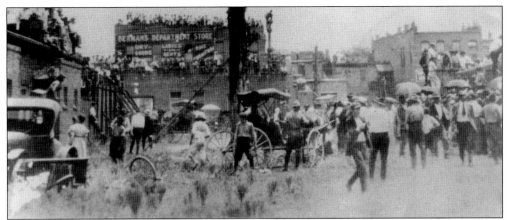

One of the bloodiest periods in the history of Anniston occurred during an eight-month period in 1914–15, when six Anniston police officers lost their lives in the line of duty. The first officer during this time to lose his life was Police Chief Harry Shiretzki; he was shot and killed in May 1914, when he and patrolman Seaborn Eason raided a crime-ridden home on Cooper Avenue. The bloodshed and lawlessness progressively got worse. The most sensational of the police murder cases was the murder of officers James W. Dashwood and William T. Dilliard in September 1914. They were killed in broad daylight while serving a warrant for the arrest of Tim Sharpe. Sharpe was tried on October 1, 1914, for the murder of the two officers. The following day, a jury of 12 men convicted him of murder and sentenced him to be hung.

On December 21, 1914, Officer Jack Holland was slain while attempting to arrest a suspect in West Anniston. The last two officers to lose their lives during this bloody time were Clarence Kettle and Marion Screws, who were gunned down in a shootout with Leland Cass, the son of a minister. Upon investigation it was impossible to determine who fired the first shot and Cass was later sentenced to one year in prison for manslaughter. Tim Sharpe was hung June 25, 1915, at the jail and protested his innocence until the end. A wall was built around the scaffold so no one could see, but people stood on cars, buildings, and trees to view the hanging. It was not until Tim Sharpe was hung that the city was brought under control and the "purification by fire" ended.

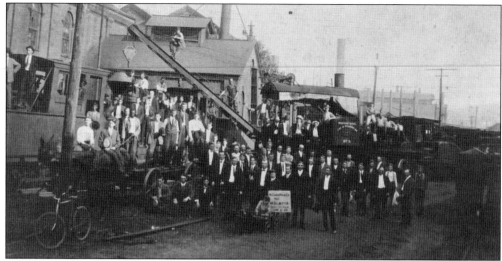

Dr. J.L. Wikle was the first fire chief in the city of Anniston. A small chemical engine was the only fire protection and since it required someone with knowledge of chemicals to keep it charged, it was parked by a shed at Wikle Drug. In 1884, the city council was officially notified of the organization of the Daniel Tyler Hose Company #1 and the Glen Addie Hose Company #2, forerunners of the fire stations at city hall and F Street. The Daniel Tyler Company's president was D.T. Goodwin and the Glen Addie Company's president was J.M. Waters. Later, companies #3 and #4 were founded. Company #3 was an all African-American fire station and Company #4 was the forerunner of the West Fifteenth Street station. The companies were like social organizations, where the men paid dues. Company #4 even organized a band of about 30 pieces. The volunteer fire department used hand reels and ran to the fires on foot. The Volunteer Fireman's Association held annual tournaments with drills and races each year where Anniston teams competed.

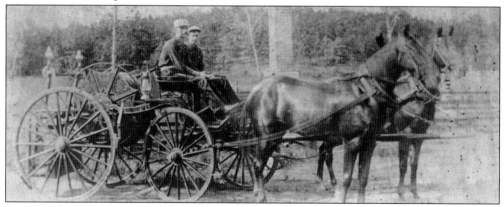

In 1885, the city council appointed a committee of 3 to buy 500 feet of hose, reel, and other equipment for Company #1 and Company #2. The Anniston City Land Company gave the land at Fourth Street and Pine Avenue for the Glen Addie station and the city did not allow building costs to exceed $2,000. Space for Company #1 was provided at city hall when it was built in 1888. In February 1885, the council committee drew up an ordinance creating the city fire department. The city set up 3 horse-drawn reels with paid drivers and an electric alarm system in March 1886. The horse-drawn reels cost about $900. Throughout Anniston there were fire alarm boxes to call the fire department. The boxes were placed in all wards of the city, the schools, and the major industries. Water mains were laid in 1887.

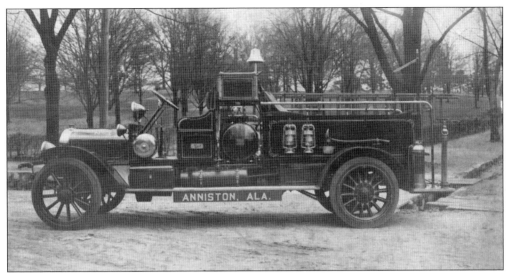

In 1912, the city purchased its first motorized fire equipment, a Mack hose truck with chemical equipment. The volunteer companies disbanded in 1914, so a full-time paid department was organized. Its first chief was D.C. Rainwater, who retired in August 1942. By 1914 horses were no longer used by the fire department. In 1945, the department consisted of 20 full-time firemen manning three fire stations. In 1947, a Seagrave truck with a 65-foot ladder was purchased. This truck was replaced in 1978 with a Seagrave 100-foot ladder. The Anniston Fire Department hired the first female firefighter in 1992. Currently, it operates four fire stations.

Health was a major concern of the city of Anniston. As far back as 1874 a physician, Dr. J.W. Guin, was employed by the Woodstock Iron Company. After the town was open to the public in 1883, a city physician was part of the city government. Some of the early city physicians were J.L. Simpson, T.A. Davis, and J.C. Moore. After the courthouse was moved to Anniston, a county physician was employed. By 1913, the Calhoun County Health Department was established and headed by the health officer. The health department was responsible for immunization, sanitation, inspection, extermination, education, and treatment. The county health official kept an office in the courthouse annex until around 1945, when a health department building was constructed at 1106 Gurnee Avenue. In 1966, the health department moved to 309 East Eighth Street. Eventually, the department outgrew this site, and it moved to 3400 McClellan Boulevard in the late 1990s.

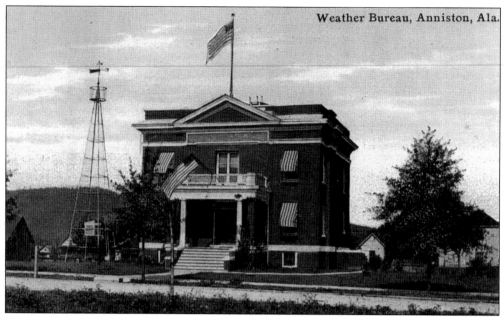

Weather Bureau, Anniston, Ala.

On September 1, 1891, a weather station was established at Coop Station in Oxanna. The designation of the weather station was changed to Anniston in February 1903, but the actual station remained in Oxanna. The U.S. Department of Agriculture established a regular weather bureau station at Anniston on October 16, 1905, at 913 Quintard Avenue. The weather bureau remained at that location until the station at 720 Quintard was completed in 1907. Starting in 1905, detailed weather and climactic data was kept. The station made the information available for public use or to businesses thinking of locating in Anniston. All observations were discontinued at the end of March 1949, but weather bureau personnel remained in the building to provide general public service. In July 1952, the weather bureau moved into rented spaced at 1330 Noble Street as an economy measure. The weather bureau building on Quintard Avenue was eventually torn down.

The city stables were located behind the city municipal building on Gurnee Avenue. Horses were vital to the city in the late 1890s and early 1900s. Until 1914, the fire department still used horses to pull fire reels. The police used the animals for mounted patrols and wagons. Horses and mules were used to pull all forms of city transportation, such as the city sanitation wagons. Horses were also used to pull the streetcars until motorized trolleys were installed. By the 1920s, the stables gave way to the car barn.

Howard W. Sexton was the receiver for both the Anniston Gas and Light Company and the Anniston Electric Company around 1896. Both companies shared an office at 915 Wilmer, and by 1898 the gas and light plant was located on the corner of Third and Noble Streets. The gas and light company supplied coal, gas, and incandescent light. Heat gas for electric stoves was sold in addition to gas coke used for fuel. The company also supplied power for engines, electric motors, and for manufacturing purposes, as well as operated a street car line, the Oxford Lake Line. By 1900, the two companies had merged and were under the guise of the Anniston Electric and Gas Company. The company powered two street railways lines, the Oxford Lake Line and the Noble Street Line. Around 1917, the Alabama Power Company took over operations of all gas and electric power in Anniston. However, by 1931 the Alabama Power Company turned over the gas supply to Alabama Utilities Service Company at 917 Noble Street. Around 1938, the gas supply fell under the control of the Alabama Gas Corporation, located at 1221 Noble Street.

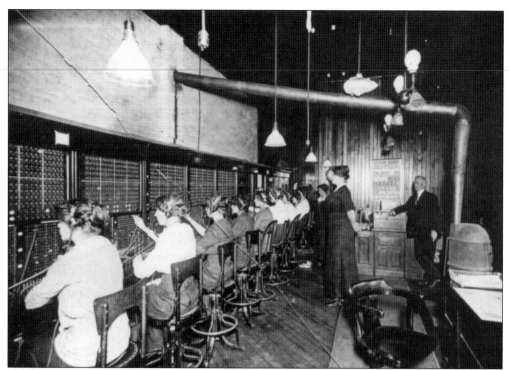

Telephones appeared in Anniston in the 1880s. The early telephone companies were the Noble-Pan Electric Company, operated by real estate and insurance agent Sam Brewer, and the Bell Telephone Company, operated by electrician Joseph Dozier. By 1896, the Anniston Telephone Exchange was located at 909 1/2 Noble Street with P.G. Seaman as manager, but in 1898 the exchange became simply the Southern Bell Telephone Company. By 1900, over 100 telephones were provided by the Bell Telephone Company. Southern Bell Telephone and Telegraph operated at 24 East Twelfth Street and was under the management of H.P. Watson in 1908. The telephone company continued to operate on East Twelfth Street until around 1953, when the operation moved to Noble Street.

Five

INDUSTRY

At the conclusion of the Civil War the major "industry" in Anniston and Calhoun County was farming. Reconstruction brought Northern investors to the South in an effort to establish major industries to make use of the natural resources. The first industry to take advantage of the rich ore deposits during Reconstruction was the Woodstock Iron Company, when they built their first charcoal furnace in 1873. The company produced charcoal pig iron, so it attracted other metal working industries. In 1881, the Anniston Manufacturing Company was built to employ the wives and children of the iron company. As a result, Anniston became a metal working and textile industry town.

In mid-1883, the Nobles relocated their car wheel works from Rome, GA. Other metal working industries that located in Anniston in this period produced products used by the railroads, such as car wheel works and railcars. In 1889, the Anniston Pipe Works was built under the direction of Charles Noble. In 1893, the Hercules Pipe Company moved its plant from Pell City to Anniston. By 1899, Hercules was renamed the Central Foundry Company and produced soil pipe for plumbing and drainage purposes. In addition to this type pipe, another Anniston pipe company, the Radford Company, produced pressure pipe used for water mains. Thomas Kilby organized the Clark and Kilby Company, later Kilby Locomotive and Machine Works, around the turn of the 20th century. By the 1920s, the pipe and metal working industries were flourishing.

In 1919, Alfred Lee and his brothers started Lee Brothers Foundry as a cast iron shop, but quickly switched to brass production. Another metal working industry, M&H Valve and Fittings, established a plant on West Twenty-third Street in 1925. M&H Valve, founded by Whitfield Clark, L.B. Liles, and W.P. Acker Sr., among others, was the only plant in the South to make a complete line of valves and fittings for water works, sewage disposal, and fire protection products.

Textiles were also important to the Anniston economy in the early years of development. The textile industrial development in Anniston hastened after 1893 when the state legislature passed tax legislation favorable to the textile industry. By 1896, American Net and Twine had established a company in Anniston to produce twine and netting for the fishing industry. In 1899, the Anniston Carpet Mill Company produced the first yard of carpet in the state of Alabama. The year 1900 saw three mills establish themselves in Anniston: the Anniston Yarn Mill, the Adelaide Mill, and the Woodstock Mill. One factor that greatly helped the textile industry in Anniston was the abundance of pure lime-free water that powered the mills. By 1920, Anniston was home to nine different textile mills that employed almost 1,200 people.

Like the metal-based industries, many of the textile industries closed. Of the industries that remained some have moved from their West Anniston locations to other parts of the county.

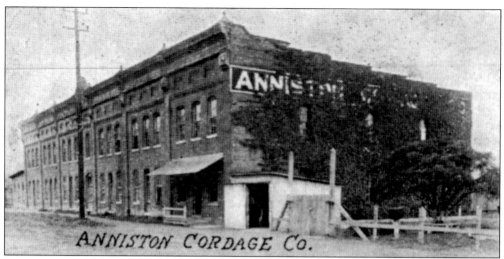

ANNISTON CORDAGE Co.

Anniston Cordage was organized around 1892 with William H. Zinn as president. In August 1893, it started the production of cotton rope and cord. It was sold in 1902 to the George B. Carpenter Company of Chicago and in turn was sold to the Samson Cordage Works of Boston in 1909. Located at 318 Noble Street, the company manufactured solid braided-cotton cord used for sash cord, clotheslines, and webbing. In 1920, additional land was purchased and the mill was expanded and modernized to include a new three-story addition. The mill assumed the name of the parent company, Samson Cordage Works, in 1960, and used that name until the plant closed in 1993. (Courtesy of *Anniston and Calhoun County, Alabama*.)

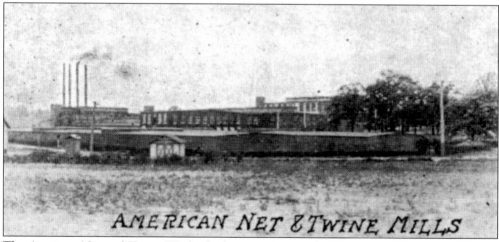

AMERICAN NET & TWINE MILLS

The Anniston Net and Twine Works, built in 1896, was a branch of the Massachusetts-based American Net and Twine Corporation. The plant was located in northwest Anniston, near Blue Mountain. There was a mill building, a warehouse, and 15 cottages in the complex and Charles M. Noble was the manager. The plant commenced operation in 1897 and doubled in size the following year. The net and twine works went through many name changes and owners, but the name most associated with the company is Blue Mountain Industries. The current owner, Hicking Pentecost, changed the name to the Barbour Thread in 1997. The company produced net and twine primarily for the fishing industry. As of 2000, all that remains of the Anniston complex is the netting division. (Courtesy of *Anniston and Calhoun County, Alabama*.)

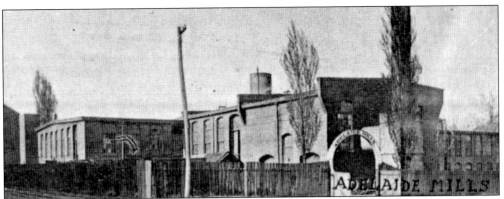

Adelaide Mill was founded in 1900 by Thomas R. Robinson. The plant was located at 129 West Seventh Street on the site of the old Woodstock Iron Company. Robinson had timberland and a sawmill in South Alabama that cut timbers to specification. They were then hauled to Anniston for the construction of the mill. The mill used the furnace #1 engine room as a machine shop. The company's primary product was cotton yarn, a raw material used by local mills. Adelaide Mill started with 2,500 spindles, but no weaving was done at the plant. The early products of the mill were used in boy's stockings. This was a time when boys wore knickers with knee-length stockings. During the Depression, meetings were continually held to either shut down the plant or buy a leather belt, which was driven by a steam engine that in turn drove the large staff that ran the mill. By 1936, the company marketed their product to the crochet business in California and Hawaii. Four years later a dye machine was installed, since the company felt the future was in dying. By 1947, the company had expanded to 11,040 spindles and 5,000 twisting spindles. Adelaide Mill remained under the ownership and management of the Robinson family until 1980. In 1984, the mill faced foreclosure and in 1986 it was auctioned. (Courtesy of *Anniston and Calhoun County, Alabama*.)

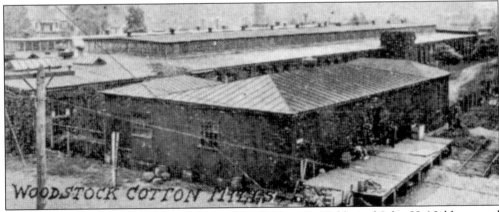

The Woodstock Cotton Mill was organized by William S. Noble and John H. Noble around 1900. It was located at 130 West Seventh Street adjacent to the Adelaide Mill, and used raw materials produced by the Adelaide Mill to manufacture cotton table damasks, towels, and yarn. By 1929 it had become a division of the Calwood Corporation. It closed in the late 1930s and opened in 1942 as the Woodstock Spinning Corporation. It closed again for a time after World War II, then reopened around 1951 as Woodstock Enterprises, which manufactured cotton and rayon cloths and weaving products. Robinson Brothers, which owned the Adelaide Mill, acquired the property around 1956 and turned it into the Robinson Brothers Warehouse. The warehouse was foreclosed on along with the Adelaide Mill in the 1980s. (Courtesy of *Anniston and Calhoun County, Alabama*.)

Textile mills were prevalent in Anniston and they outlasted many of the iron work plants. Among some of the early textile mills were the Anniston Carpet Mill Company, organized by Edmund L. Tyler and Associates in 1899, and the Anniston Yarn Mill, organized in 1900 with W.A. Scarbrough as president. The textile mills, by the 1920s, employed almost 1,200 people and were a solid base for the Anniston economy. However, the textile industry faced economic hardship in the 1980s that forced some mill closures in the Anniston area. (Courtesy of *Anniston and Calhoun County, Alabama*.)

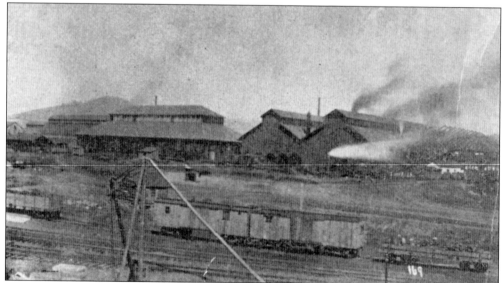

In 1882, the Nobles, principally John and William, moved their foundry from Rome, GA, to Anniston. The foundry produced car wheels, axles, steam engines, and heavy castings. The two-story brick machine shop measured 50 by 150 feet and had an 80-by-215-foot forge. The buildings were equipped with modern conveniences, including hydraulic cranes. The car wheel foundry, which had two cupolas with a melting capacity of approximately 40,000 pounds per hour, turned out 300 car wheels a day. The machine shop had the ability to bore wheels, turn axles, and construct engines and heavy machinery. It was operated by a 120-horsepower Corliss beam engine.

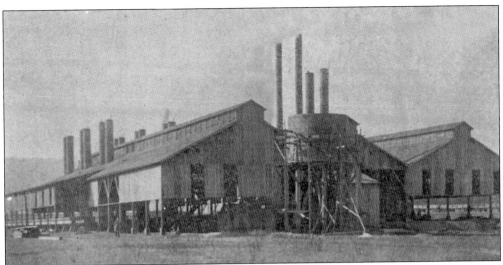

The Nobles' rolling mill included a steam forge for making car and locomotive axles. The mill contained three steam hammers and a 200-horsepower engine for driving the rolls, which made scrap iron into muck bar ready for the steam hammer. It was one of the largest and most complete car wheel works in Alabama in the 1880s. The company guaranteed the wheels for 50,000 miles.

John, Charles, and Dixon Noble operated the Noble Brothers Foundry at the corner of Tenth Street and Mulberry Avenue. By 1890, the United States Rolling Stock Company in Anniston consisted of the former Noble Brothers plant and the Alabama Wheel Works. The Rolling Stock Company plant was valued at $250,000 in 1890. The company turned out 25 freight cars per day and 8 passenger coaches per month. The car wheel department, rolling mill, and forges supplied the car wheel works in Anniston and also shipped to the main plant in Illinois. The Anniston plant encompassed 40 acres and employed over 1,200 men. It was located in Anniston because of the proximity to Woodstock Iron Company, a source of pig iron.

The Anniston Soil Pipe Works, located at the end of Twelfth Street in west Anniston, was organized in 1887, with Charles M. Noble in charge. Noble was the former superintendent of mines and furnaces at Woodstock Iron. The first pipes manufactured at the plant were reportedly used to lay 8 miles of water mains for the city of Anniston. By 1890, the plant was in full operation, but the financial troubles of Woodstock Iron impacted the Anniston Soil Pipe Works. The business was leased by a Cincinnati company and reorganized as Radford Pipe and Foundry in 1891. (Courtesy of *Anniston and Calhoun County, Alabama*.)

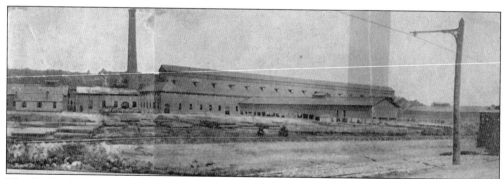

The Radford Pipe Company was organized and leased by a Cincinnati company in July 1891. The company was originally part of Woodstock Iron, but was severed from the company due to a reorganization to save the iron works. Radford Pipe was under the supervision of J.K. Dimmick and employed about 450 men. A year after being acquired, the company prospered and was shipping its product all over the country. In December 1893, the plant was sold again, this time to F.C. Miller of Newport, KY. The plant still succeeded even though it went through several ownerships. Radford Pipe merged with the U.S. Cast Iron Pipe Company in 1899. Unfortunately, the company was a causality of the Depression and it closed in 1929.

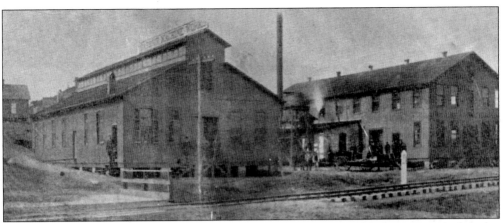

The Barbour Machine Works was established in Anniston in May 1888. Cotton gins and cotton presses were manufactured by the company, which eventually expanded to make condensers, cotton seed crushers, general machinery, and also architectural castings. Located on west Fourteenth Street near the L&N Railroad tracks, A.L. Smith managed the company. It was no longer in operation by 1898.

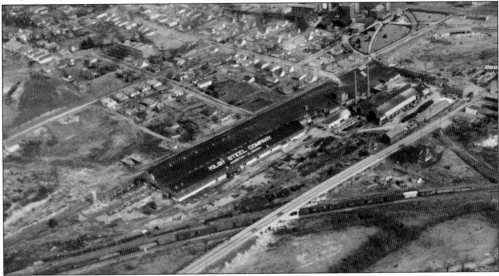

In 1889, the Clark and Kilby Foundry was organized to manufacture railcars and tracks for the logging and sawmill industry. In 1892, Thomas Kilby and Oscar Smith reorganized the foundry operation under the name of Smith and Kilby as a railway supply company that manufactured cane cars for Cuban sugar mills. They also made car and track items for the mainline railroads, and continued to make railcars for the logging and sawmill industry. The foundry was located on west Tenth Street. Around 1903, the foundry was reorganized as the Kilby Locomotive and Machine Works. At this point the company produced standard and narrow gauge railroad cars. All of the Kilby railroad cars were constructed of raw materials produced by local manufacturers. By 1929, the company was simply known as the Kilby Steel Company. During World War II, Kilby Steel produced artillery shells, cartridge cases, rockets, and anchors. Kilby Steel sold the firm in 1968 to the FMC Corporation of Chicago. FMC produced steel castings and forgings. The company also was involved in chemical and oil products. The name of the company officially changed from Kilby Steel to FMC in 1972. FMC sold out in 1994 to United Defense, which manufactures track used on U.S. Army and Marine tanks.

Central Foundry, located at Eleventh Street and McDaniel Avenue, originally started as the Hercules Pipe Company. The pipe plant was founded in 1891 at Pell City, AL, by industrialists from Boston, MA. Pell City lacked skilled iron workers, so the company failed and was foreclosed on in 1893. A group of Anniston citizens persuaded the investors to relocate the company to Anniston, with the citizens group paying the relocation costs. The Hercules plant was located on West Eleventh Street near McDaniel Avenue. The Boston investors briefly headed the company, which was leased by the Tyler family shortly after 1893. In 1898, the Tyler family, particularly Alfred Tyler Jr., started expansion plans that were completed in 1899. Upon completion of the expansion, the company was renamed Central Foundry. The foundry manufactured cast-iron soil pipe and fittings until the plant shut down shortly after World War II. (Courtesy of *Anniston and Calhoun County, Alabama.*)

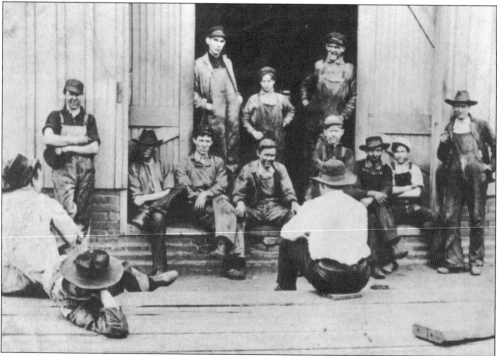

The problems facing the city's iron foundries in the 1890s were numerous. Local ore supplies were exhausted. The surrounding forests had been cut over, diminishing the fuel supply. To relieve some of the problems raw materials were brought over private railroads from out-of-county properties, but this was costly. Charcoal furnaces were on their way out in the 1880s and coke furnaces were taking their place. Many speculated that one day steel would supplant pig iron in importance. As a result the iron plants died out and Anniston depended more heavily on its textile mills.

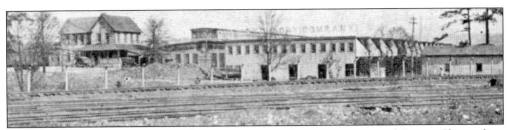

In 1907, Union Foundry was built and placed under the management of George Shumacher. The company, located on Seventeenth Street and Clydesdale Avenue, manufactured "great white way" light posts. The posts contained five lamps enclosed in glass globes with one globe located in the center of the post and the others at the four corners. The company also produced three lamp and one lamp versions. The "white way" lamp posts were used to light Pennsylvania Avenue from the White House to the Capitol in Washington, D.C. Anniston was known as "The City That Lights The World." W.M. Byrd of the Hammond-Byrd Iron Company and Otto Agricola of Gadsden bought the Union Foundry in 1918. In 1924, the company was consolidated with several foundries in the area under the name Alabama Pipe Company. The company was prosperous during the 1920s and even into the 1930s, but after World War II the pipe shops were barely operating. In 1952, Union Foundry was rebuilt with five Herman Rol-O-Cast machines. Along with this upgrade the mechanize fitting unit from the Ornamental Foundry was moved to Union Foundry. It was thought that decentralization of the operation was necessary to meet competitive circumstances. In 1959, the Alabama Pipe Company, of which Union Foundry belonged, merged with the Woodward Iron Company of Birmingham, AL. Union Foundry still operates as a division of Woodward Iron. (Courtesy of *Anniston and Calhoun County, Alabama.*)

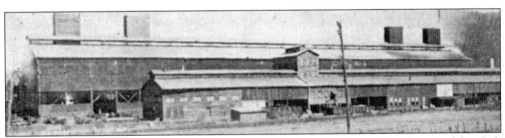

The Southern Manganese Corporation, at 130 West Tenth Street, was organized by Col. Theodore Swann in 1914, with a stock of $3,000. Swann built an experimental electrical furnace to manufacture ferro-manganese, an alloy that when used in steel strengthens the metal by giving it greater tensile durability. Ferro-manganese was used by the Anniston Steel Company for making shells at the Anniston Ordnance Company and the rest was shipped to Northern steel mills. Southern Manganese planned for four blast furnaces designed by company engineers and imported South-American ore to use in the furnaces. An output of approximately 20 tons per day was expected. The plant moved to Seventh and Duncan Streets around 1924, but after 1926, it kept business offices in the Liles Building. Around 1927, the company switched to producing chemicals, especially polychlorinate biphenyls (PCBs). By 1935, the company had merged with Monsanto, a world-wide company based in St. Louis. Monsanto manufactured chemicals, plastics, petroleum products, man-made fibers, and electronic instruments. In August 1997, the company began operating under the name Solutia. (Courtesy of *Anniston and Calhoun County, Alabama.*)

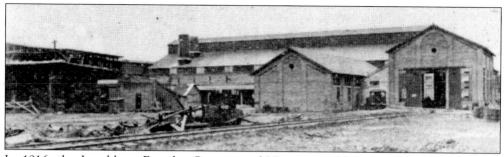

In 1916, the Lynchburg Foundry Company of Virginia established a water-pipe plant in Anniston. The plant was located at Alexandria Road and the L&N Railroad. Lynchburg Foundry was a pit-cast plant with two pits that manufactured 2 to 12 inch pressure pipe for water and gas distribution. The pressure pipe came in 12-foot lengths. In 1920, the company was acquired by the Alabama Pipe and Foundry Company. The company was part of the 1924 merger of numerous foundries that formed the Alabama Pipe Company. During the 1930s, the plant operated sporadically and by 1945 was closed. Lynchburg Foundry got a new lease on life in 1948. The plant was rebuilt and renamed the Water Pipe Plant. The company installed three De Lavaud Centrifugal Casting Machines, which were capable of producing pipe sizes ranging from 3 to 24 inches. In 1959, the company was part of a merger that joined the Lynchburg Foundry, along with several of the Alabama Pipe Company holdings, with the Woodward Iron Company of Birmingham, Alabama. The Woodward Iron Company merged in 1968 with the Mead Corporation who operated the water pipe plant until it closed in 1972. (Courtesy of Anniston and Calhoun County, Alabama.)

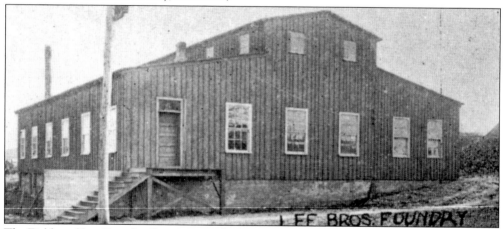

The Fields and Lee Foundry Company was built by Alfred Lee and his half brother, Edward Field, in 1917. The company was originally constructed as a cast-iron pipe plant. In 1919, Arthur Lee joined the company upon the death of Edward Field and the company name was changed to the Lee Brothers Foundry Company. Within a short time after its founding, the company switched to brass manufacturing, which was closely connected to the pipe industry. In 1946, the company was incorporated with Arthur Lee as president. The foundry, located at Seventeenth Street and Walnut Avenue, was added to the original 20-by-60-foot building to accommodate the expanding company. Arthur Lee did the molding and Alfred operated the furnace. The company operated in straight flow production so nothing, including time, was wasted. During World War II, the company made navel supplies. When the company reconverted after the war, it started making brass plumbing supplies. In 1952, it moved from its location in west Anniston to a larger plant on Golden Springs Road, where it currently operates. (Courtesy of *Anniston and Calhoun County, Alabama.*)

Six

SCHOOLS
AND CHURCHES

Both education and religion were important to the town founders. Almost immediately after the founding of the town, a two-story brick structure was built for a school and church. The first attempt at public education came on September 4, 1883, when Mayor T.H. Hopkins made a motion to establish three schools. Heilemon Wilson was in charge of the white boys' school and Kate Wilson was in charge of the white girls' school. The third school established was a mixed African-American school with H.W. Conley as principal. In 1883, F.M. Hight was selected the first school superintendent. On January 28, 1891, the state legislature made Anniston a separate school district. The new school superintendent was Dr. John W. Abercrombie, who introduced graduation in the schools.

In 1912, the Anniston system added electricity to the schools. The following year, the PTA was implemented. On June 22, 1926, the city voted to purchase land for an athletic field named for W.F. Johnston. Thirteen years later, Memorial Stadium was constructed.

Schools were integrated under court order in the 1960s.

Overcrowding has always been a terrible problem that forced constant additions and new buildings to be constructed. The last new school elementary school was Randolph Park, built in 1965. In 1970, Anniston High School was built; it was followed in the mid-1980s by Anniston Middle School.

In addition to the public schools, there were also numerous private schools. In the 1880s, Samuel Noble established two schools connected with the Episcopal church: Noble Institute for Boys and Noble Institute for Girls. For African-American students, there was the Anniston Normal and Industrial School, which was located at 323 Walnut from 1898 to around 1915. In the early 1900s, there was a private girls' college in the old Anniston Inn and a private boys' preparatory school run by the Presbyterian church. Most of these private schools did not last very long and closed due to lack of students and lack of finances.

Anniston also had several post-secondary schools. The Harry M. Ayers Trade School, designed by a Montgomery architectural firm, was built near Golden Springs in 1965 for $913,800. Classes commenced in June 1966 and the school was dedicated the following June. As the college expanded, the name eventually changed to Ayers State Technical College. In the 1980s Gadsden State Community College renovated the old Noble Street Elementary School to house a branch of the college. Jacksonville State University drew many students from the Anniston population since it was located only 12 miles north of the city.

Religion was another major concern for the founding fathers. In 1874, Rev. J.F. Smith of Talladega conducted the first Episcopal church service in Anniston. In 1879, the first Catholic mass was held. Even though the two denominations organized services soon after the founding of the town, the actual churches were not built until after the town opened in 1883. Other denominations soon followed in organizing and building churches. Many of the early churches formed missions in other sections of town that led to the development of other churches.

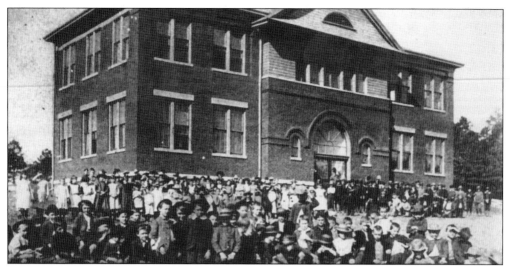

On August 12, 1887, a lot at 1226 Pine Avenue was purchased for $1,000. A building contract was awarded to Badders and Britt for approximately $6,800. The school building, the first in the Anniston public school district, was completed in June 1888. By the time Pine Avenue Grade School was completed, the school population had already outgrown the building. W.Y. Titcombe was the principal and Mary Allen, Eliza Jeffers, and Kate Culliman were teachers. To ease some of the overcrowding, additions were made in 1916. The school closed in 1961.

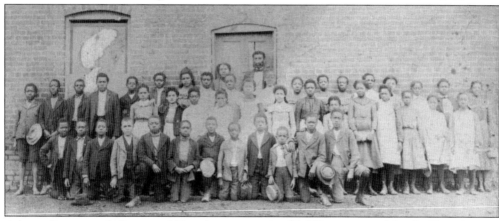

A lot at Seventeenth Street and Pine Avenue costing $1,500 was secured for the Pine Avenue School, which focused on the public education of Anniston's African-American children. On December 6, 1889, a contract for $4,000 was issued and the school was completed in time for the 1890 school session. H.W. Conley, who died in 1891, was named principal and was replaced by S.E. Moses. J.S. Simmons, Julia Stephens, and Lila Smith were the first teachers at the school, later called the Seventeenth Street School (shown above). Cobb High School was built in 1935 for $60,000 to alleviate overcrowding. When Seventeenth Street was condemned and removed in 1936, the students moved to the Twelfth Street School. Seventeenth Street Elementary School was the only African-American school until 1904, when the Fifth Ward School for blacks was constructed. In 1921, the Sixth Ward school replaced the Fifth Ward School. Nora Zanders was instrumental in initiating the plans for a school building to replace the school at an African-American Presbyterian church on S. Leighton. Funds for the South Highland School building were raised through various means. Nora Zanders remained involved in education, and when Cooper Elementary was built in 1952, she was named its first principal.

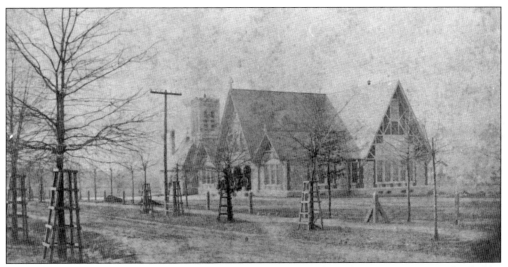

The Noble Institute for Girls, located at Eleventh Street and Leighton Avenue, was funded by Samuel Noble in 1886 and was placed under the guidance of the Episcopal church. This meant the school had daily morning prayer and there were no classes on holy days. The boarding school was attended by girls from all over the Southeast because the school provided an education from grammar school through college. Tuition was $2 for the primary grades, $3 for the secondary grades, and $4 to register for college courses. Noble Institute offered classical, scientific, and general courses in addition to special courses in drawing, music, and foreign languages. The school burned in 1894, but was quickly rebuilt.

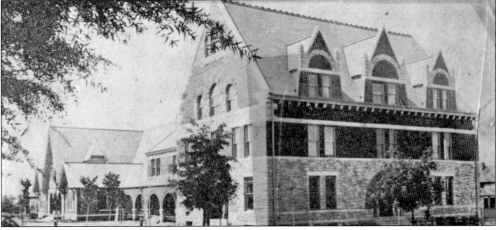

The Noble Institute girls' dormitory, constructed in 1889 as a memorial to Samuel Noble, had a dining room off the first floor. Two students lived in each of the bedrooms on the second floor. The principal's family stayed in a suite of rooms separate from the students. Occupying the third floor was the music room, study room, library, art museum, and gym. In 1914 the Episcopal diocese could no longer operate the school, and the boarding school closed. The day school remained open until 1922. After the school closed, the dormitory was operated as a rooming house. In 1951, the Episcopal Day School was created. The building burned in 1965, but was rebuilt. During the 1976–77 school year the Episcopal Day School merged with the Anniston Academy to form the Donoho School. The elementary school remained at the day school until 1980, when the Donoho Lower School was completed off Henry Road. Grace Church currently uses the building for a parish hall and Sunday school.

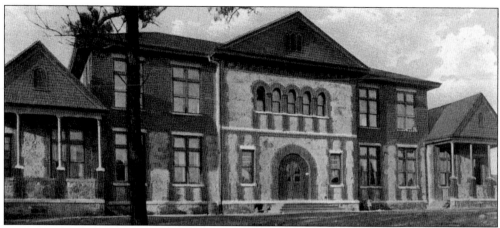

Leighton Avenue Public school was originally the Noble Institute for Boys. Samuel Noble funded this private school for boys under the auspices of the Episcopal Church. The school was a gray stone and red brick building with a long circular driveway in the front, located on a hill at the current site of the Stringfellow Hospital. It opened in October 1887 for second through twelfth grades with a course study that included technical, classical, and business classes. Tuition was $3 for the primary grades and $4 for the rest of the courses. Because enrollment was low, the school was leased to the city in 1896 and renamed Noble High School. In 1900, the city converted the building into a grammar school. The school, except for a small laboratory, burned on January 31, 1910, and was not rebuilt.

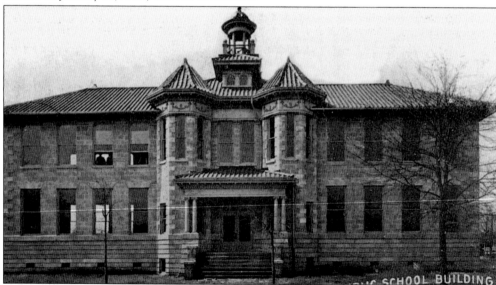

The Wilmer Avenue Public School, located between Fourteenth and Fifteenth Streets, was added to the system after 1900 to help alleviate overcrowding. A high school did not exist in Anniston from 1900 to 1906, so in 1906 four rooms were added to the Wilmer Avenue School to house the public high school. In 1910, displaced students from Leighton Avenue attended school in the afternoon at Wilmer Avenue. Eventually, Quintard Avenue School was built to alleviate the overcrowded conditions. Wilmer Avenue housed first grade, second grade, and the high school grades. The October 14, 1951 opening of Johnston Jr. High School allowed for the closing of the Wilmer Avenue School. The Wilmer Avenue School building was used from 1954 to 1956 as Sacred Heart of Jesus Catholic School.

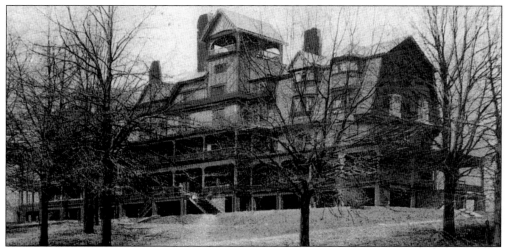

When the Southern Female University in Birmingham burned in 1892, the school relocated to Anniston. Since the Anniston Inn was vacant, the school took up residence there in December of 1893, with H.G. Lamar placed in charge. The school had over 100 boarding students in 1894, but financial problems forced the city to take the school over in 1897. When the city took over the school it was renamed the Anniston College for Young Ladies. The college had a preparatory department in addition to a conservatory for music and art. There were several headmasters during the school's 13-year history. The last was Dr. C.J. Owens, who served from July 1903 until May 1906, when the school closed. The school conferred degrees in bachelor of arts, bachelor of letters, bachelor of music, and awarded teacher's certificates in music, violin, and bookkeeping.

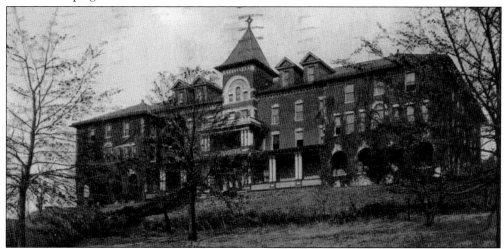

One of the many private schools in Anniston was the Barber Memorial Seminary, named for philanthropist Margaret Barber and located in Oxanna. The school was built at Allen Avenue and Fifteenth Street at a cost of $415,000. Shortly after the school opened in November 1896, it was destroyed by fire. The school was rebuilt and reopened in 1898 under the administration of the Board of National Mission of the Presbyterian Church (northern). Barber Seminary instructed African-American girls in religion, domestic art, and household science and was staffed by white instructors. By 1920, the school had 250 students, but it closed in 1942 mainly due to the lack of funds and adequate enrollment. The building was torn down in 1953 to make room for a housing project.

A private college under the auspices of the Presbyterian Synod of Alabama opened in 1905. The Alabama Presbyterian College was on an 11-acre site at Eighth Street and Leighton Avenue, which was later the location of Johnston Jr. High School. This was a standard college that conferred B.A. and B.S. degrees. The school, a massive gray brick building, was dedicated on November 15, 1906, with two departments: preparatory and college. The Bible was a required subject. The costs in 1905 were $120 for boarding, $50 for tuition, $25 for room rent, contingent fees of $5, a breakage fee of $5, and lab fees ranging from $5 to $11. Not far from the main building was the two-story headmaster's home. In 1917, the school was made coeducational, but faced financial troubles. The cost of operations increased and forced the church to discontinue the college, so for the 1918 fall term it was made into a preparatory school. In 1922, the school changed its name to the Anniston University School to reflect it was a preparatory school, but it lasted only one more year. (Courtesy of the *Alabama Military Institute Prospectus*.)

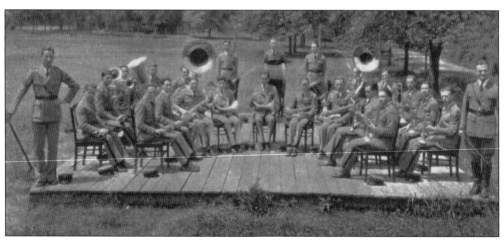

A new headmaster, Col. Edward B. Fishburne, arrived in 1923 at the Alabama Military Institute (AMI), formerly the Anniston University School, and remained at the school until it closed after 1935. The school remained under the maintenance of the Synod of Alabama. In 1926, the school added a structure to house classrooms, a lab, a gym, and a swimming pool. The daily regimen of the school was run on a military schedule. Reveille was at 6:15 a.m. A religious service was held daily. The dormitory had a large parlor, dining room, and bedrooms with steam heat and electric lights. The AMI band was directed by G.T. Overguard and was renowned throughout the state. The band's local concerts were popular with Anniston residents. (Courtesy of the *Alabama Military Institute Prospectus*.)

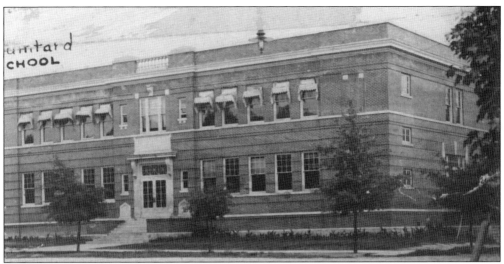

Quintard Avenue School was built in 1912 to relieve the overcrowding in the Anniston system caused by the fire at the Leighton Avenue Public School. The construction cost was $14,975. The school was originally used as an elementary school. From 1944 until 1951, it served as a junior high school and housed only the seventh grade. It was converted back to a grammar school in 1951. The school closed around 1969, but housed the annex for the high school until 1971. The building was torn down and made the site of the Centennial Memorial Park, which includes numerous monuments as well as the arches from the Anniston High School Auditorium that was torn down in the 1980s.

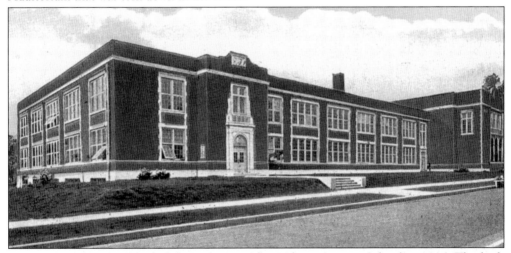

Anniston High School had its beginnings in the Wilmer Avenue School in 1906. The high school moved in 1914 to a former church called "the barn" at Fourteenth Street and Wilmer Avenue. In September 1921, a lot between Sixteenth and Seventeenth Streets facing Leighton Avenue was purchased for $15,000 and a construction contract for the high school was awarded to a Chattanooga firm for $142,000. A brick building (shown above) trimmed with Indiana limestone was completed in mid-term 1922 with 10 classrooms, the office of the superintendent, an 800-seat auditorium, and a gym. An addition to help alleviate overcrowding was completed in 1935 with the assistance of a WPA loan. By 1971, a $3.6 million open-classroom school was built on Woodstock Avenue. The complex incorporated the Kilby House, a $1,475,000 vocational complex, a 2,500-seat gym, and a 1,000-seat auditorium.

Noble Street Elementary School at 2125 Noble Street was added to the Anniston School System in 1925. To help alleviate overcrowding, the school completed additions in 1927 and again in 1939. It closed around 1974. The building sat vacant until 1981, when Gadsden State Community College selected the site for a branch of the college. The building was renovated and now houses the Anniston branch of the community college.

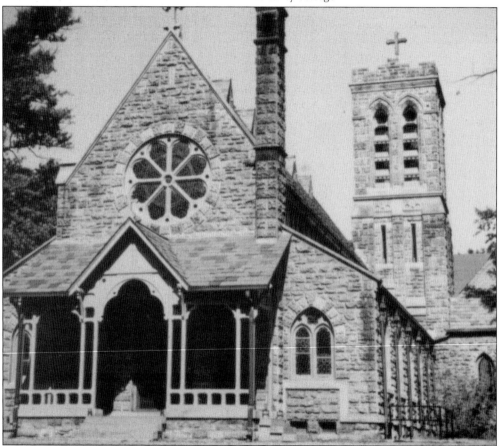

Grace Episcopal Church was designed by New York architect George Upjohn. The Gothic structure consisted of a slate roof, tower, and Rose windows, in addition to the exterior masonry of Simon Jewell. According to legend, the sanctuary was based on a church where General Tyler had worshiped in Highland Falls, NY. The church was dedicated on Christmas of 1885 with Rev. Wallace Carnahan in charge. Plans for the church's porch were abandoned and a temporary wooden structure put in place. The porch was torn down when the church was remodeled 70 years later. In 1887, the rectory at 1023 Quintard Avenue was completed and furnished.

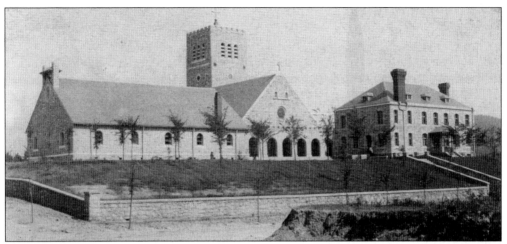

St. Michael's and All Angles Episcopal Church, located at Eighteenth Street and Cobb Avenue, was built by John Ward Noble and dedicated to the memory of his parents, James and Jennifer Noble, and his brother Samuel. William Halsey Wood of Newark, NJ, was commissioned to design the structure. The cornerstone was laid October 15, 1888, and dedicated by Bishop Richard Wilmer of Mobile on September 29, 1890, during the feast of St. Michael's and All Angels. The 4-acre property included a sanctuary, parish house, assembly room, and rectory, connected by cloisters and all surrounded by a stone wall. The cost of the Romanesque structure was $125,000. The Rocky Hollow sandstone used in the construction of the church was quarried near Anniston and cut by stonemason Simon Jewell. John Ward Noble, his wife, and his parents were all buried in the courtyard of the church.

The sanctuary of St. Michael's Church seated approximately 850 people. The ceiling, an exact replica of a ship's ribs including bracings and struts, was hand carved from long-leaf pine by Bavaria woodcarvers. Angel heads were carved on the ends of the corbels. The altar was carved from a 12.5-foot slab of Carrara white marble imported from Italy. The reredos, standing 26.5 feet tall, were carved from alabaster with statues of archangels Michael, Gabriel, and Raphael placed in niches. At the top of each of the seven reredos were angels each bearing a symbol of events in the life of Jesus. The theme of the life of Jesus continues in the series of memorial windows in the sanctuary.

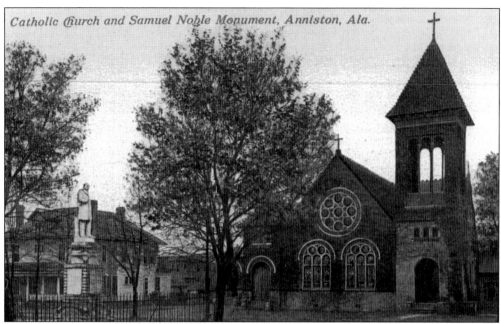
Catholic Church and Samuel Noble Monument, Anniston, Ala.

Sacred Heart Catholic Church was first ministered to by Jesuit priests from Selma. By early 1885, a small frame church was built on Third and Spruce Streets by the 60-member congregation. Grace Episcopal Church sold the Catholic church a lot next to the Grace Rectory at the corner of Eleventh Street and Quintard Avenue. The building, constructed under the financial assistance of William H. Zinn, was dedicated on November 19, 1899, by Bishop Edward P. Allen of Mobile. In April 1922 the Ku Klux Klan burned Sacred Heart Church (shown above). With Northern financial aid, local donations, and insurance payments, a new church was built in 1923. The rectory was completed in September 1927. In 1997, the church was sold and relocated to Golden Springs, where a new sanctuary was dedicated in 1999.

Mount Zion Baptist Church was organized in 1879. The buildings, constructed by church members themselves, were built between 1890 and 1894. The stone, like many other church buildings in Anniston, came from the local Rocky Hollow quarry. Rev. Augustus A. Battle, later the principal of the Anniston Normal and Industrial School, served the congregation during the construction of the church in the Zion Hill neighborhood at Second Street and Walnut Avenue. Another significant church in the African-American community was the Seventeenth Street Baptist Church, which was organized in 1880 as the Concord Baptist Church. The congregation purchased a lot on the corner of Seventeenth Street and Cooper Avenue, and in 1902, when the church was built, its name was changed to the Seventeenth Street Baptist Church. It played a paramount role in the African-American community and served in the 1960s Civil Rights movement.

Temple Beth-el ("House of God") was a single-story Byzantine-style building with arched transom doorways and arched windows. A small corner lot at 301 E. Thirteenth Street was secured for $1,500. The Ladies Hebrew Benevolent Society, organized December 10, 1890, played a major role in the building of the synagogue. The society held a bazaar, strawberry festival, and oyster supper to fund the synagogue. The church was completed for approximately $2,700 and dedicated December 8, 1891, by Dr. Max Heller of New Orleans. The Ladies Hebrew Benevolent Society deeded the property, lot, and synagogue to the congregation on September 11, 1907.

St. Paul's Methodist Episcopal's cornerstone was laid in 1888 at Fourteenth Street and Leighton Avenue. Simon Jewell was again called upon to be the stonemason for the construction of the sanctuary. The construction cost for the structure was about $26,000. By the time of World War I, St. Paul's congregation had disbanded. In 1921, the church building was sold to the First Christian congregation, which had been organized by Dr. E.C. Anderson in 1885. The church building was in bad repair. The congregation repaired the church, redecorated the interior, replaced the electric lights, put new glass in all the windows, and installed a heating system. The congregation purchased a parsonage at 1321 Leighton Avenue in 1926. A small fire damaged the basement in 1935 and a more serious fire in 1963 forced the church to remodel the interior.

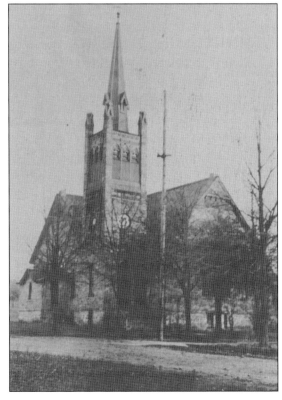

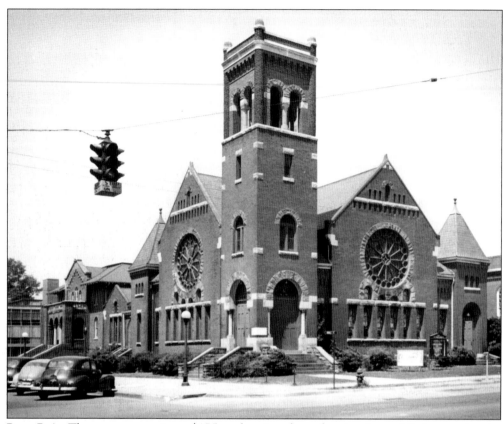

Rev. R.A. Thompson was given $175 and assigned to the Anniston Mission station by the Methodist Church in 1881. He held services at Lloyd's Springs, near the Anniston Manufacturing Company. A short time later, the congregation moved to the west side of Noble Street between Twelfth and Thirteenth Streets. When it rained the First Methodist congregation worshiped either at members homes or in a nearby blacksmith shop. In 1882, the Woodstock Iron Company donated two lots on the northwest corner of Noble and Twelfth Streets. The building was a 40-by-60-foot building with a crude pulpit and rough pine-slab seats, equipped with candles for night worship. The Sunday school was organized the same year, with Simon Jewell as superintendent. Under Reverend Alonzo Monk, the church was completed and furnished about 1889. On Easter 1891, the church burned. The church traded the two lots on Twelfth and Noble Streets for two lots on Fourteenth and Noble Streets. In 1893, a brick church was constructed by C.J. Houser and John Swain. Around 1903, the church organ, which ran by bellows and later water, was built and installed (it was rebuilt and electrified in 1936). A new educational building was added to the church in 1917. The last services in the sanctuary were held on April 24, 1955; the church was demolished the next day. The congregation broke ground for a new church building on the Fourteenth and Noble Streets' lot on July 10, 1955. Over the next two years a $750,000 modern facility was constructed. It was dedicated on April 21, 1957, by Bishop Bachman G. Hodge of the North Alabama Conference.

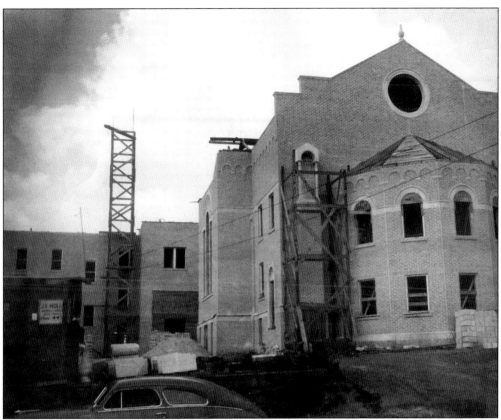

The First Baptist Church of Anniston was organized in 1884 by Rev. E.T. Smythe. The first church building, destroyed by a storm, was a single-story clapboard church with Victorian scroll work. In 1902, the congregation built a wood structure, later brick veneer, at the corner of Fourteenth Street and Pine Avenue. This church was destroyed by a fire that started in the furnace room on November 19, 1945. While a new building was being constructed, the congregation met in a tent; when it became too cold to worship there, they moved to the county courthouse. In 1947, the congregation voted to move to 105 West Fifteenth Street to be nearer to the center of town. Thomas West Gardner designed the new church, which cost $187,999. The main auditorium had an electric organ, and with the main floor and the balcony had a seating capacity of about 700. In the 1950s, additional land next to the church was purchased to provide a parking lot and later a building expansion. The members of the church who chose to stay at the Fourteenth Street and Pine Avenue location built Pine Avenue Baptist Church on the lot.

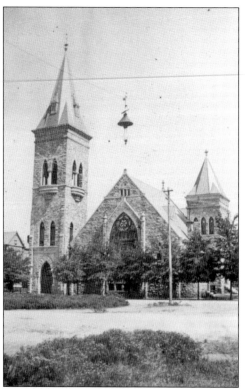

Parker Memorial Baptist Church was organized in 1887 at the Opera House with a charter membership of 45 people. The cornerstone for the church was laid on July 3, 1888, following the purchase of a lot at the corner of Twelfth Street and Quintard Avenue. The building, designed by George Kennerly with Simon Jewell as its stonemason, cost approximately $85,000. Its interior was constructed of Italian wood. It was occupied on January 1, 1889, and named Twelfth Street Baptist Church. In October 1889, the name was changed to Parker Memorial, since Duncan T. Parker financed the construction of an additional large sanctuary in memory of his late wife and young son. The sanctuary, completed on March 29, 1891, was furnished with pews, carpet, a pulpit, a pipe organ, gas fixtures, and stained-glass memorial windows. As the church has grown through the years, offices and administrative buildings have been added and connected by cloisters. Parker Memorial now encompasses the entire block between Twelfth Street and Thirteenth Street on Quintard Avenue.

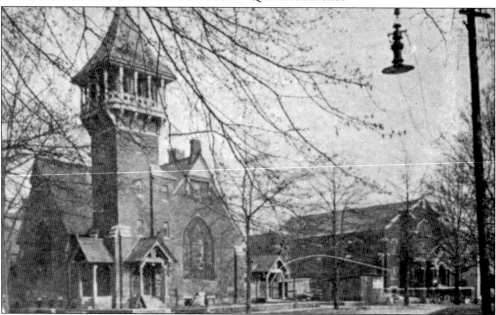

The First Presbyterian Church was organized March 9, 1884, with 21 members and Rev. J.D. McLain. The tower and addition were attached to the church in 1894. The Sunday school was organized March 24, 1884, with W.H. Williams as superintendent, but the educational building at the church was not built until 1919. In 1959, the church relocated to a modern structure at Tenth Street and Henry Road. (Courtesy of *Anniston and Calhoun County, Alabama*.)

Seven

DAILY LIFE

Samuel Noble's city harkened back to his English heritage. The Noble and Tyler family built English-style estates on the east side of Anniston. These massive houses and gardens were designed by Northerners to pay homage to estates back in England, and they typified the Victorian era.

Noble also built his workers' homes. The cottages were neat and well kept and their close proximity forced a family atmosphere. The workers' cottages, however, were not the lavish homes of the founders. The homes were typically four rooms with an outhouse in the back. Company housing was segregated. The African-American workers lived in what was called "Smoky Row," which was west of Furnace #1 and Furnace #2. Smoke from the furnace hung over the housing area and probably accounted for its name. Another section of African-American housing, Furnace Hill, was located behind the coke furnaces. White workers lived in Glen Addie and in Cottage Row, a group of small houses that extended south along Noble Street near Seventh Street. Woodstock Iron paid its workers between 80¢ and $1, while other companies paid 60¢ wages, because Woodstock Iron management believed that if a man was well paid, he was less likely to steal. As more industries located in Anniston, mill villages sprang up near the foundries and mills.

Almost immediately after the town opened, various fraternal organizations were founded. The Knights of Pythias and the Elks were among the organizations that had chapters in Anniston. In addition to fraternal organizations, various labor unions were organized. There was also a golf club around the turn of the 20th century that later became the Anniston Country Club. The Young Men's Christian Association came to Anniston as the result of World War II.

Transportation on Anniston's streets changed over the years. In the early years a street car with iron wheels pulled by a pair of mules traveled a route from Fourth and Noble Streets, came west to Fourth and Pine Avenue, and then turned north and crossed the creek on a bridge between Glen Addie and Mulberry. Wagons were used for deliveries well into the 20th century.

Communication was an important aspect of life in Anniston. The telegraph arrived with the railroads. Radio arrived in 1938 when Harry M. Ayers added WHMA to his Consolidating Publishing Company. The station went on the air on November 3, 1938, at 100 watts. The studios were located at 1330 Noble Street, and by 1939 were broadcasting on the air full time. In 1942, the station was part of the old NBC "Blue Network," later ABC. Starting as early as 1964, Consolidating Publishing planned for a TV station, which became a reality in 1969. WHMA-TV 40 signed on the air October 26, 1969, at 12:00 p.m. with test patterns and then at 12:30 p.m. aired an AFL football game between the New York Jets and the Boston Patriots. The first full day of operation was October 28, 1969. The station became a CBS affiliate in the mid-1970s. In 1983, the television station was sold to Jacksonville State University and the call letters were changed to WJSU.

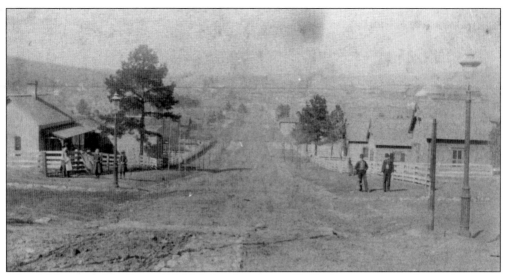

Glen Addie, named for Samuel Noble's daughter, was a 20-block section in southwest Anniston. Woodstock Iron built cottages for the workers and sold the homes at actual cost, as well as on a liberal reimbursement basis. The homes were neat and comfortable with ample room for an outhouse and a garden in the rear and a lawn and flower beds in the front. Rows of water oaks lined the streets. In the 1870s and 1880s the area was a white working-class neighborhood. One of the early volunteer fire companies was in Glen Addie, as was the first school. Even though the area was working class some of the more prominent members of town built their homes on the hill in Glen Addie, such as Dr. T.W. Ayers, who also ran a drug store in the Glen Addie area. In 1940, Glen Addie was the site of the first public housing, the Glen Addie Homes. Many of the old homes, first built by the Woodstock Iron Company to house employees, are no longer standing.

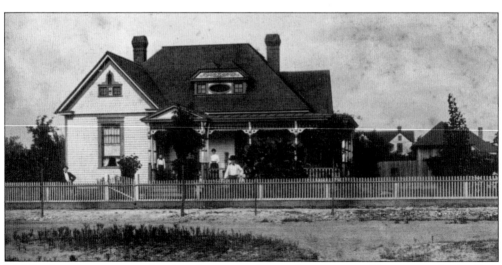

Middle-class Annistonians lived in homes similar to this one-story Victorian-style dwelling with a Queen Anne roof and a wrap around porch. This house, located at 1818 Moore Avenue around 1895, was owned by Charles Cryer, an agent for the Anniston Investment Company, which dealt primarily in real estate and loans. An example of this type of house can be seen at the corner of Eleventh Street and Leighton Avenue across from Grace Episcopal Parish Hall.

Another early residential area to develop was Marvin Hill, located between Noble Street and Moore Avenue at Fifteenth and Sixteenth Streets. The stately two-story Victorian homes were built on the hill behind the Anniston Inn. Lloyd Rivers, a commercial traveler for the Bell & Weatherly Company, built a home at 21 West Fifteenth Street. His wife, Nora Rivers, is pictured here around 1900 in front of their home with her one-horse buggy. Marvin Hill's name was changed to Circle Drive in the late 1940s. In 1948, First Baptist Church built a new structure on the site of some of the Victorian homes. The houses that are left have been used as rental property for many years.

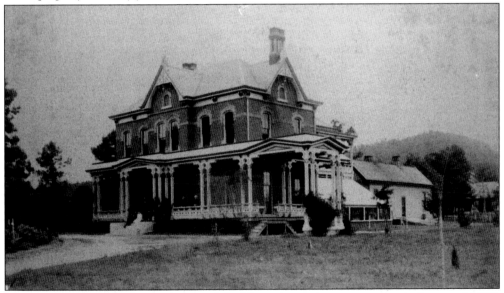

The John Ward Noble home, the site of the Westminster Apartments, was built around 1890. Noble built his three-story Victorian manor house near the home of his daughter, Lila Huger. The manor house sat prominently on a curve near Twentieth Street and Wilmer Avenue. In the 1970s, the home was used as rental apartments and was in terrible repair. It was eventually torn down and residential apartments for the elderly were built on the site in 1980.

The Huger-Brazelton House was built around 1885 by John Ward Noble for his daughter Lila and her husband, Dr. Richard P. Huger. The house, located at 1901 Wilmer Avenue, was a Richardsonian Shingle-style home designed by William H. Wood and built by the same artisans who built St. Michael's and All Angels Church. The exterior was made of dark-red brick with a dark-green cedar-shingle roof. There was an intricately carved staircase with initialed newel posts and sets of sliding pocket doors in the wide foyer. The home had a surrounding farm with pecan groves. The Huger family lived in the house for many years after Dr. Huger's death in 1922. In 1975, the house went to Huger's granddaughter, Lila Huger Brazelton. Mrs. Brazelton and her husband operated Brazelton Engineering in the home from 1970 to 1986. In 1993, Mrs. Brazelton sold the home to the Walker family.

Quintard Avenue was a residential neighborhood in the 1870s. The avenue only ran from Fifth Street to Twenty-second Street in the early years. The homes from Eighteenth Street to Twenty-second Street sat on steep banks. At first, Quintard was intended to be an outdoor botanical garden with rare and exotic vegetation. Samuel Noble brought Fredrick Ulbricht, a former supervisor at Paris' Tuileries Gardens, to Anniston in 1888 for that purpose, but before the Quintard Park could be carried out completely Noble died. In the 1920s, the avenue was paved and each side had a parking lane. Quintard Avenue became an access road for Fort McClellan in the 1940s despite the opposition of many of the residents. In 1957, Quintard Avenue was opened to the south.

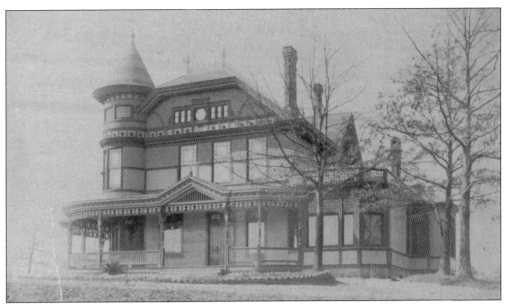

The McKleroy-Kirby home was built in 1888 by Col. John Martin McKleroy, president of the Anniston City Land Company. McKleroy built his home on the highest hill at Sixteenth Street and Quintard Avenue, a posh residential area of the time. The irregularly shaped Victorian mansion featured a three-story tourelle with rounded windows at the southeast corner, a conical roof, a wrap around porch, and a pedimented entry. In the interior, there was a center hall, side hall, and an inglenook in the foyer. On the first floor was the parlor, the music room, and the dining room, each with ornate fireplaces of base-relief glazed-tile hearths. A staircase wound upward to an artistic glass window on the landing. The second floor included four large bedrooms each with ornamental mantelpieces. The third floor was possibly designed as a ballroom, but served mostly as the attic. A guesthouse was just west of the main house. The main house, considered part Queen Anne Victorian and part Neo-Renaissance, sat on approximately 3 acres. John McKleroy died in 1894 and the house was then occupied by his son, William H. McKleroy. When the younger McKleroy died in 1919, his widow sold the house the following year at auction to William Coleman Wilson. Wilson was the manger and president of the Emory Foundry and occupied the house until his death in 1949, when Frank and Robbie Kirby purchased the home. Upon the deaths of the Kirbys in the early 1980s, the house was sold by the executors of the will, Southtrust Bank. In 1984, real-estate developers bought the house and turned it into an inn and restaurant, the Victoria. In 1988, the Victoria expanded and added rooms to the back of the main house. The stables now house the Wren's Nest Art Gallery.

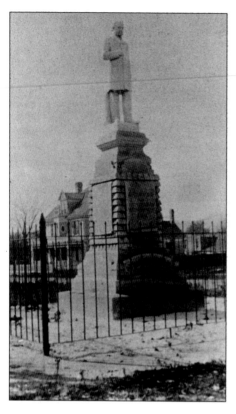

The monument at Eleventh Street and Quintard Avenue was erected in June 1895 by the city of Anniston to honor Samuel Noble. At the dedication, Samuel Noble's eldest granddaughter, Elizabeth Roberts, pulled the cord to unveil the monument. The crowd witnessing this event was estimated to be as large as 10,000 people. The presentation address was given by D.C. Blackwell and was followed by Mayor F.M. Hight's speech. There was also an oration given by John M. Caldwell, lawyer for the Woodstock Iron Company as well as the city of Anniston. Music for the unveiling was provided by the East Rome Band, a favorite for many Anniston events. Just behind the monument was the parish house for Grace Episcopal Church at 1023 Quintard Avenue, currently the Southtrust Bank building.

The Pelham Monument (shown here) was erected at Twelfth Street and Quintard Avenue in the 1890s. The tall tapering marble monument was inscribed with the dates and places of the birth and death of Maj. John Pelham. There are two other monuments at Quintard Avenue's median. At Tenth Street and Quintard Avenue is a large eagle with outspread wings perched on a globe that is mounted on a stone pedestal. This monument was erected by the William Henry Forney Chapter of the UDC to honor soldiers who lost their lives in World War I. Between Twelfth and Fourteenth Streets on Quintard Avenue, a monument was erected by the Anniston Post of the American Legion in honor of the Calhoun County men who served in World War I. It depicts an American soldier stepping through barbed wire with a rifle and grenade in his hands. (Courtesy of *Anniston and Calhoun County, Alabama.*)

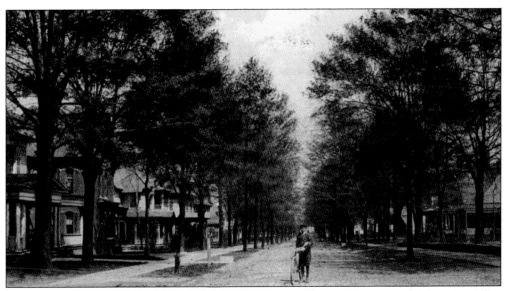

Leighton Avenue was named for a Tyler family ancestor. This could account for the reason that the family located their residences along this street. Alfred Tyler Sr. and Alfred Tyler Jr. both located their homes on Leighton Avenue. In the early days many prominent citizens located their homes on Leighton Avenue, such as Thomas E. Kilby and William F. Johnston. Leighton was also the location of Grace Episcopal Church, St. Paul's, and the Noble Institutes for Boys and Girls, as well as the Seller's Hospital. The popularity of Leighton as a residential area grew after the Calhoun County Courthouse was moved to Anniston in 1900. In the 1960s, when the area was rezoned for both medical and residential, the street changed. Homes were destroyed in favor of modern office complexes.

Alfred Tyler Sr. and his wife Annie Scott Tyler, for whom Anniston is named, moved to Woodstock (Anniston) in June 1873. Alfred was the oldest son of Daniel and Emily Lee Tyler and Annie was the daughter of Macon merchant Isaac and Caroline Paul Scott. The couple met and married in Macon, GA, in 1859. Alfred worked for several railroads and by 1872 was vice president of the South Carolina Railroad. When he moved to Anniston, he built a two-story Victorian home (shown above) on Leighton Avenue. He eventually gave the home to his son, Alfred Tyler Jr., who added a wing that included a library and billiards room. Alfred Sr. and Annie moved into a simple two-story colonial-style house just north of the original home. After the deaths of several family members, both homes were given to the city and then razed in the 1950s to make room for hospital construction. (Courtesy of *Anniston and Calhoun County, Alabama*.)

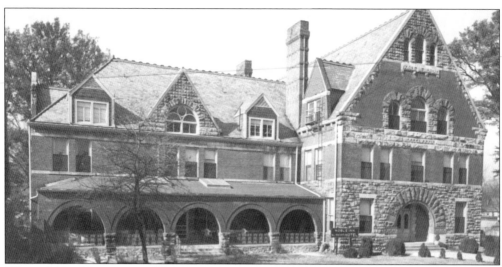

When the Noble Institute for Girls closed the boarding school's dormitory (constructed in 1889), the building was used for the Noble Apartments located at 1028 Leighton Avenue. By 1935, the building was the residence of J.W. Mallory. The building became an apartment building once again by 1938 when the Noble Arms Apartments were under the management of Blanche Mallory. The apartments remained until about 1951, when Eva Purefoy opened the Noble Inn and Dining Room. The hotel had 40 rooms that came with or without a bath, in addition to hot and cold running water.In the late 1950s, Alma Drake ran the Noble Inn Hotel. Air conditioning was added to the hotel around 1958. The building burned along with the Episcopal Day School in 1965.

The Noble-Roberts-Morris Cottage at 1001 Leighton was built by Samuel Noble around 1887. as a guest cottage for visitors and potential investors in Anniston. When Samuel Noble's daughter Kate married E.E.G. Roberts, Samuel gave the cottage to the newlyweds for a home. The house, almost a copy of Crowan Cottage, was reminiscent of a late-medieval country inn. It was made of cedar and native stone and was similar to the architectural designs of Henry Hobson Richardson and his protegee, Stanford White. It remained in the Noble family until the mid-20th century, when it was sold to Joe Morris and later to architect George O. Parker. The cottage was restored and housed Parker's architectural firm until his death in the 1980s.

Around 1887, Alfred Tyler Sr. sold approximately 40 acres of land between his home and Edmund Tyler's estate, The Pines, to Judge James Lapsley. The Tyler Hill area was one of the earliest residential subdivisions and was under the direction of the Tyler Hill Land Company. The homes were constructed, starting around 1888, of varying architectural designs, but with a definite Victorian influence. Duncan Parker built this house at 400 East Sixth Street on Tyler Hill in the 1890s for his daughter Susie and her husband, W.W. Stringfellow. The Queen Anne-style clapboard and shingle house sat next door to Parker's stately home.

"The Pines" was the home of Edmund Leighton Tyler, son of Gen. Daniel Tyler. Named for the large pine trees surrounding it, the 7,000-square-foot house was built around 1896 at Fifth Street and Goodwin Avenue. It was designed by W.T. Daniel with 27 rooms and 12 fireplaces. Some consider The Pines to be the first Neoclassical-style home built in Alabama. It included both gas and electric lighting and was also equipped with a coal-fired heating system. The Tyler family lived in the home until 1926, when it was sold to Judge Elbert Boozer (shown above). Later, it was converted into low-income apartments. During the late 1980s, the house was vacant and in July 1992 it burned. The lot remains vacant.

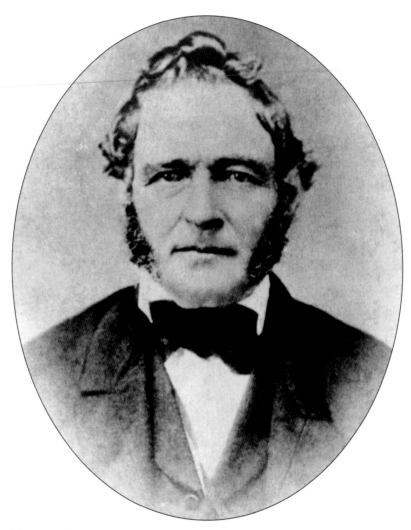

James Noble Sr. was born on April 17, 1805 in Cornwall, England, where the Noble family had lived since the 15th century. On December 26, 1826, James married Jennifer Ward. The couple had 15 children. James Sr. left England in 1837 and settled with his family in Reading, PA. In the 1840s, he invented a new type of brake for locomotives. He had also built a foundry and machine works in Reading. In 1855, James Sr. set up a foundry and rolling mill in Rome, GA. The iron works manufactured cannons for the Confederacy, so when Union general William Sherman marched through Georgia he burned the iron works. James Noble Sr. also lost his two furnaces in Cedar Bluff to the Union Army. He rebuilt and expanded his iron business after the war and then retired in the early 1870s. James Sr. came to Anniston to live and received shares in the Woodstock Iron Company. Crowan (pronounced Crown) Cottage was built by Samuel, John Ward, James Jr., and William for their parents. Mrs. Noble named the home, a modified Swiss chalet made of native stone and cedar shingles, after the family home in Cornwall, England. The house, located on Fourteenth Street and Woodstock Avenue, was not completed until after the death of James Sr., but Jennifer lived in the home until her death in 1900.

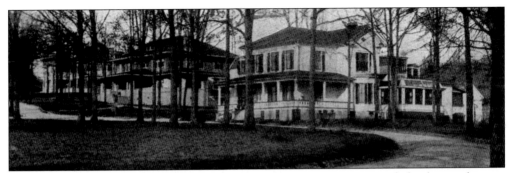

Christine Circle was originally going to be called Noble Park. It was intended to be a park, open to the public, in which the Noble family homes would be built. The street was a long circular road that started around Twelfth Street and ended approximately at Sixteenth Street. After 1905, a road was cut through and named Woodstock Avenue. Samuel Noble's home (right) was located at about Twelfth and Woodstock. Next to Noble's house was Sen. Fred Blackmon's home (center). Blackmon was instrumental in Camp McClellan being located in Calhoun County. The home, last owned by J.H. Edmondson, burned in the 1930s. Judge J.J. Willett's home (left) was the last on the block. Educational Park currently sits on the site of the homes.

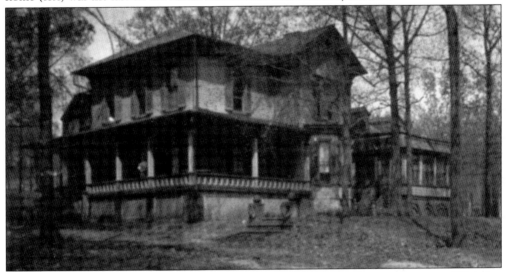

Samuel Noble's home was built around 1882 by George Noble on what was known as Christine Circle. Samuel bought the house from George before it was completed. A double row of trees was planted from the home to Grace Church at Samuel's request. After Samuel's death, his daughter, Josephine Keith, acquired the house and remained in it with her family until around 1900. The Easthams bought the house and added the remainder of the upstairs at the rear of the house, including an upstairs sitting room used for gambling. A dentist named Dr. Lightwood bought the house in the 1920s. Lightwood changed the exterior facade of the house by removing the porch and replacing it with columns on the front and sides, giving the house a more classical appearance. Dr. Gerald Woodruff Sr. bought the house in 1947 from Judge Charles Klein's widow. In 1965, Dr. Woodruff Sr. gave the house to his son Dr. Gerald Woodruff Jr., and his growing family. Dr. Woodruff Jr. started an extensive renovation of the home, but the school board obtained the property for a new high school. In 1967, before the family was able to move the home to Golden Springs, a fire broke out that ruined the roof, most of the second floor, and the heart-pine floors. Dr. Woodruff was still able to relocate the house, however, by dismantling and rebuilding it on the new site.

Samuel Noble's home was elaborately decorated with mantles, chandeliers, and molding that accented the rooms. A unique iron mantle was in the middle bedroom upstairs. The master bathroom had marble flooring. When the house burned it was in the process of being dismantled and as a result many of the original fixtures were saved, including the fixtures of the master bath. A fragment of the medallion shown in the parlor ceiling was rescued and a new set was made, from a plaster cast, to replace the ones lost in the fire. The property included not only Samuel Noble's home, but also a carriagehouse and a servant's house located at the rear. The carriagehouse was a barn that eventually was converted into a four-bedroom home and occupied by Dr. and Mrs. Gerald Woodruff Sr. Both the carriagehouse and the servant's quarters were moved to Golden Springs with the main house.

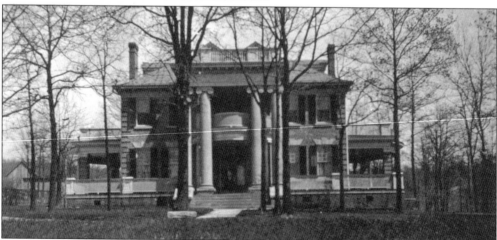

Broadview, the home of Judge J.J. Willett, was built around the turn of the 20th century. The Greek Revival-style house was located at 1325 Woodstock Avenue. Willett lived at 1400 Quintard until Broadview was built. Judge Willett was born in Carrollton, AL, and was a graduate of the University of Alabama. He read law in his father's office and decided too many family members were practicing in Carrollton, so he moved his practice to Anniston. Willett came to Anniston in 1883 and remained here until his death in 1955. Around World War I, Judge Willett was offered the office of chief justice of the Supreme Court, but he declined the position, preferring to stay in Anniston.

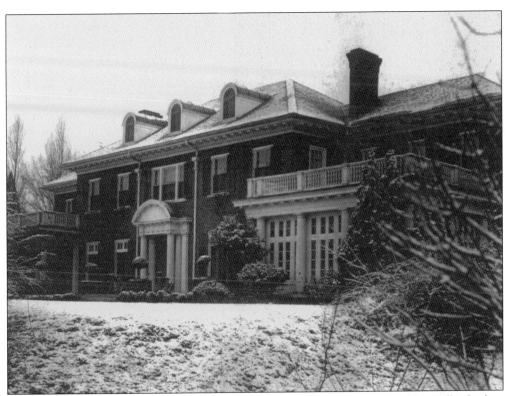

Thomas Kilby originally made his home at 600 Leighton Avenue. In 1914, Kilby built a new home (currently the annex at Anniston High School) at 1201 Woodstock Avenue. He employed the architectural talents of Warren-Knight and Davis of Birmingham to design the home. The extensive grounds included formal gardens and a swimming pool. The house, of red brick and adorned with green shutters, sat on a curve of the drive behind brick gates. The Georgian Revival-style home was balanced by its wings and a pair of columned white porches. It was built the same year Kilby was lieutenant governor. Kilby came to Anniston in the 1880s as a clerk for the Georgia Pacific. He then started the forerunner of Kilby Steel in the 1890s and served the city as mayor from 1905 to 1909. He served the state as governor from 1919 to 1923. After his term in the governorship, he lived at his home on Woodstock until his death in 1943. Mrs. Kilby remained in the home until her death in 1962. By 1966, the house was incorporated as part of the Woodstock Education Park and Anniston High School, which opened in 1971. (Courtesy of Mrs. T.E. Kilby Jr.)

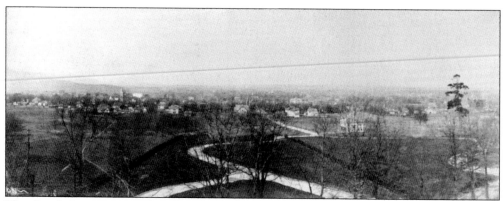

Woodstock Avenue came about between 1905 and 1908. Before this time the area was known as Christine Circle. Homes built on the circle had a splendid view of Anniston. This view was taken around 1900, approximately from Fourteenth Street. In the 1960s, the east side of the Woodstock area was taken and used as Educational Park, which houses Anniston High School and the Anniston City Board of Education.

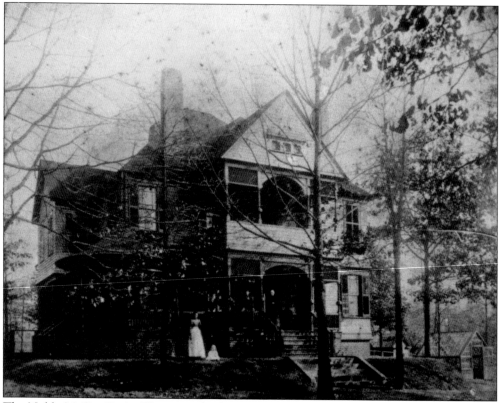

The Noble-McCaa-Butler House was built at 1025 Fairmont Avenue around 1885 by George Noble, the brother of Samuel Noble. The Victorian, Queen Anne Spindle-style home was sold to William L. McCaa and his wife, Addie Noble McCaa, shortly after it was built. In 1941, the home was inherited by their daughter Addie and her husband, Frank Butler. When Mrs. Butler died in 1988, the house faced an uncertain future. A year after Mrs. Butler's death the home was turned into a bed-and-breakfast inn by Robert Johnson. In 1991, the Johnson family sold the home and a series of owners kept the home as an inn.

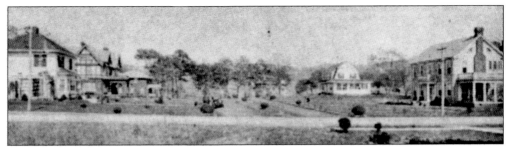

Glenwood Terrace was developed around 1922. The street had a median down the center and was lit with single-globe white-way posts. Glenwood started at Highland Avenue and ran for a block east toward the mountainside. Some of the early stately homes were occupied by the *Anniston Star*'s Harry Ayers, Walker Reynolds, baker E.C. Lloyd, and Coca-Cola Co. manager Joseph Eros. By 1930, houses were on several blocks of Glenwood Terrace. (Courtesy of *Anniston and Calhoun County, Alabama*.)

Golf did not garner a great deal of interest in America until the 1880s, and then it was a game for the wealthy. Golf clubs started springing up all over America. The Anniston Country Club started around 1908 as the Highland Golf Club with John B. Knox as the president and Lansing T. Smith as the secretary and treasurer. The clubhouse, on Sixth Street and Highland Avenue, was a two-room structure, one of which was a pullman kitchen. The clubhouse was expanded and on June 8, 1910, the formal opening of the Anniston Country Club was celebrated with a costume ball. The club offered not only golf, but also tennis and swimming facilities.

The area around the country club started growing in the 1920s and 1930s. The location was close enough to downtown for a short commute, but the setting gave the feeling of living in the country. In 1966, Fairway Drive was connected to Glenwood Terrace and furthered the growth of the area around the country club. The area has been home to many prominent Annistonians of the past and present.

Sunset Drive overlooked the Anniston County Club and was developed by the Sunset Land Company of Anniston. Hillyer Robinson founded the land company around 1922 to develop an upscale subdivision 5 miles from downtown Anniston. The homes built by the land company had wonderful views of the city and the subdivision wound around the Choccolocco Mountains. The land company moved from the offices of the Adelaide Mill to 70 Sunset Drive in the early 1950s. By 1953, the land company was closed. The T. Scott Roberts' home, Casa Alta (shown above), was part of the development on Sunset Drive. The Spanish-style house was built in the 1920s. T. Scott Roberts married into the Robinson family and later was president of the Adelaide Mill.

110

During Anniston's early days most people stayed in boardinghouses, where patrons let a room and ate in common with the other tenants. When Anniston was a young town there were numerous boardinghouses and many catered to a specific clientele. The boardinghouses began to decline in the 1930s. During the post-World War II era, efficiency apartments largely replaced the boardinghouses. The Russell Efficiency Apartments, shown above, were built around 1948. Located at 714 Quintard Avenue, the apartments had one room, a kitchenette, a bath, and a closet. B. Clyde Russell managed the apartments for many years. In 1969, the apartments changed their name to the Preston Apartments. By 1975 they were no longer listed as occupied.

The land in front of the Anniston Inn on Fourteenth Street and Gurnee Avenue was used as a parade ground for soldiers stationed at Camp Shipp in 1899. Anniston used the area as a baseball field in the early 1900s for a semi-pro team competing in what was known as the Southeastern League. For a few months in 1904, baseball legend Ty Cobb played for the club. He was paid $65 a week and roomed at Edna Darden's boardinghouse at 1020 Quintard Avenue. By 1908, the area was the Anniston Baseball Park. In the 1920s, Anniston had a baseball club that was affiliated with the Alabama-Georgia League. The baseball area (shown above) was turned into a park named for William Zinn, who left a generous portion of his will in 1923 to establish the Anniston Park System. In 1938, Anniston obtained a pro baseball team, the Anniston Rams (Ramblers). The club was a Class B team in the Southeastern League and played at the new Johnston Field. The club suffered heavy financial losses in 1949, which forced a change in the organization. In 1950, poor attendance forced the franchise to be returned to the league. The Anniston Rams disbanded in July 1950. (Courtesy of *Select Views of Anniston.*)

This renovated servants' house was located at 1206 Quintard Avenue, in the Alley. The house rented for $35, c. 1930s. This type of housing was what most laborers in Anniston could afford during the Depression. The laundry on the clothesline was the only method available for the occupant to dry their clothes. Even as late as the 1940s, some still had to live in homes like these, because they could not afford or find other housing.

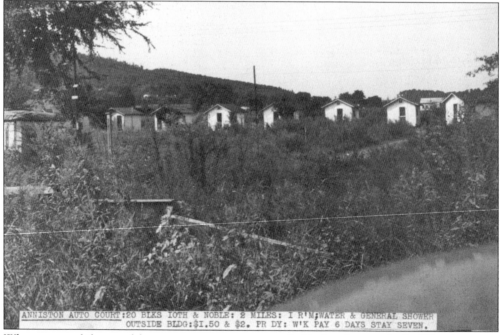

ANNISTON AUTO COURT:20 BLKS IOTH & NOBLE: 2 MILES: I R'M;WATER & GENERAL SHOWER OUTSIDE BLDG:$1.50 & $2. PR DY: W'K PAY 6 DAYS STAY SEVEN.

When automobile travel became more common, road side hotels were built. The Anniston Auto Court, a cluster of one-room cottages, was built around 1938 at 1101 South Noble Street. James Cassidy was the manager. In this tourist camp, a patron paid for one room with running water. The camp guests used a general shower. For $1.50 to $2 per day a patron had an outside building. In 1951, the auto court moved to 1403 South Noble Street with Samuel P. Cummings as manager. Ross C. Knighton Jr. assumed the managerial position in 1956. The auto court moved for the last time in 1958 to 1431 South Noble Street. In 1980, the auto court finally closed, mostly due to the rise of motel chain operations that offered reliable accommodations.

Bicycles were a major means of transportation for Annistonians prior to the turn of the 20th century. In the 1880s, chain driven bicycles were introduced to replace older bikes, which had huge front wheels. This change of design made bikes irresistible and even led to the formation of bicycle clubs. Bicycles were extremely popular with women as well as men. In 1899, over 400 bike licenses were issued in Anniston. Licenses cost 35¢, unless owners failed to secure them within a certain time, in which case they cost $1.50. Eventually, the bicycle's popularity diminished and they became children's toys.

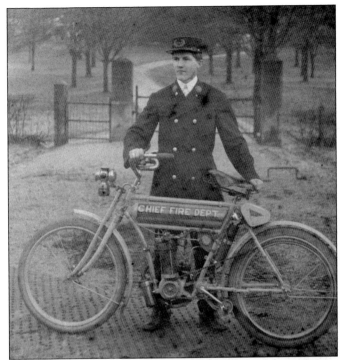

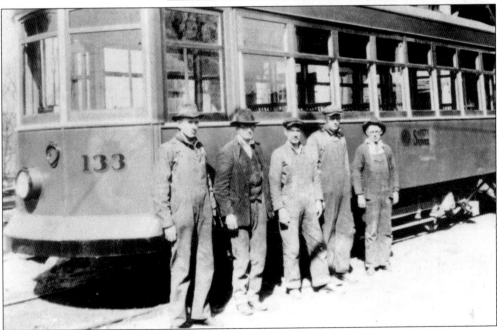

Street cars came to Anniston in 1887 when the city contracted J.W. Bigsby to provide a street railroad. In 1888, Anniston Electric Railway construction began and a central station was located on Moore and Eleventh Street for charging batteries and switching trolleys on the lines. Animals were used on the lines until 1889, when they were replaced by steam-dummy engines. In 1890, Ogden E. Edwards franchised to operate a street car line on Noble Street from Tenth Street to Twenty-fifth Street and to the western corporate limits.

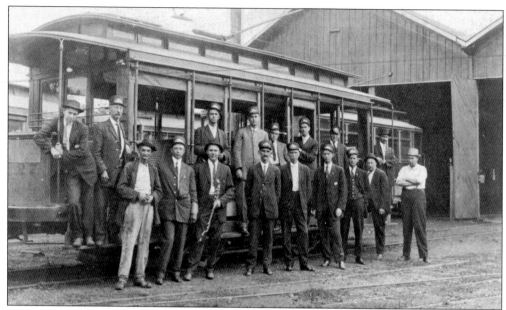

When the street car line failed it was sold by First National Bank to Howard W. Sexton and Associates around 1896. Sexton ran the trolley as part of the gas and electric company. During the summer an open car ran the line while in the winter the closed cars were used. In 1912, Alabama Power got the car system, but they lost money due to passengers on the Cresent Stage line and various taxi cabs. The last run of the trolleys was April 19, 1932. Several miles of streetcar rails were taken up and used as scrap during World War II. Buses replaced the trolleys and by the 1970s the buses were replaced by family cars. Today a few mass transit buses can be seen in Anniston, but not like their heyday of the 1940s and 1950s. The street car barn at Sixth Street and Wilmer Avenue was torn down in 2000.

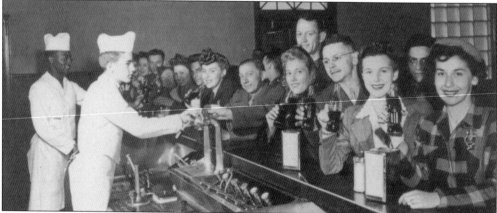

In March 1887, a YMCA was organized with W.H. Williams as the president. By 1890, the group had moved to 1004 Noble Street. The upper rooms were opened from 9 a.m. to 10 p.m. everyday except Sunday. On Sunday there was a gospel meeting where only men were allowed. The group disbanded before 1896 and a YMCA would not become part of Anniston again until World War II. In January 1941, W. Paul Alexander, a representative of the Army and Navy Department of National Council of Young Men's Christian Associations (YMCA) in the United States, came to establish recreation facilities for the 7th Division of the National Guard stationed at Camp McClellan.

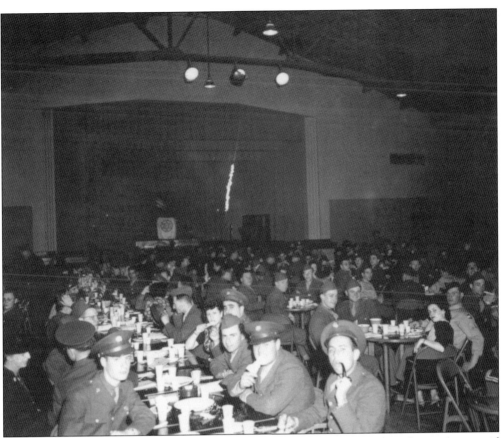

YMCA funds from New York combined with local contributions were used to pay rent and other expenses. The YMCA club went under the guise of the United Service Organization (USO). Serving on the first local board of management was Dr. C. Hal Cleveland as chairman and William H. Deyo was vice-chairman. The first location of the YMCA was 112 East Twelfth Street between Quintard and Wilmer Avenues. The building had a snack bar below and space for dancing, games, and other recreations on second floor. In 1944, the American Legion purchased the lot, so the YMCA moved to the upstairs quarters at the corner of Wilmer Avenue and Tenth Street. When the USO announced in August 1945 that it would no long sponsor the YMCA, corporation papers were filed following the reorganization of the USO under the Young Men's Christian Association of Anniston. Dr. Cleveland was elected the president of the first board of directors. A fund-raising campaign for a building was launched around 1947. The building, constructed in 1952 at Fourteenth Street and Moore Avenue, included a kitchen, dining room, health clubrooms, library, and lounges. In June 1957, an indoor pool was added, which brought the value of property to about $600,000. The primary purpose of the organization was to develop the Christian character in the community.

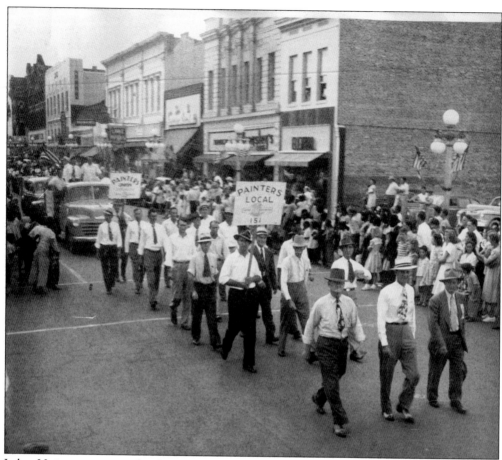

Labor Unions were part of early Anniston history. As far back as 1908, labor organizations were listed in the city directory. Among the labor organizations were the Anniston Trades Council, the Amalgamated Association of Iron Steel and Tin Workers, the International Association of Machinists, the International Brotherhood of Blacksmiths, and a typographical union. By 1913, post office clerks and letter carriers both had unions in Anniston. Just before World War I, Anniston had the Central Labor Union, the Federal Labor Union, the Molders Union, the Plumbers Union, and two textile workers unions. The unions continued to form in Anniston and during the 1970s and 1980s, strikes by various Anniston unions occurred.

Eight

MILITARY

The site of Anniston has served the military since 1862, when the Confederate government built the Oxford Iron Furnace to make iron for munitions. After the Union army burned the furnace in 1865, it was not rebuilt.

When Anniston was opened to the public in 1883, a military rifles company, Anniston Rifles Co. D, 3rd Infantry, was organized as Alabama State Troops. The second company, Woodstock Guards Co. E, 3rd Regiment, was organized around 1888. These military companies were volunteer companies under the guise of the Alabama National Guard. The two groups had armories in the 1000 block of Noble Street. The National Guard has continued throughout the history of Anniston and the current armory for the 151st Engineer Battalion Co. D is located at 2501 Quintard Avenue.

In 1898, the United States entered the Spanish-American War. With a peace agreement stalled, the federal government needed a site to quarter troops, and Alabama was a logical choice because Mobile was the port of departure for deployment to Cuba. Anniston received the quartering site in late August 1898, and Camp Shipp, a temporary camp, was established north of Anniston in Blue Mountain. The training camp was phased out by spring 1899, but this was not Anniston's last brush with the U.S. military.

In 1912, at the urging of Congressman Fred Blackmon, the Blue Mountains were used for artillery practice for the Alabama National Guard. After four years of study, the federal government bought the property northeast of Anniston in 1917. Construction on Camp McClellan started in the summer 1917. In 1929, the camp was designated a permanent fort.

During World War II, Pelham Range, a 22,168 acre tract, was purchased as a training ground. Fort McClellan was designated as a replacement training center for troops, while also serving as a German POW camp. The fort was placed in custodial status in 1947. By 1950, the fort was restored to active status as a training ground for the National Guard. It served as the chemical corps school and as the training site for the Women's Army Corp (WACs) and military police. Congress decided to close and move Ft. McClellan's chemical and military police schools to Fort Leonard Wood, MO. The fort officially closed on September 30, 1999. The federal government will eventually turn over the deed to the land to the city of Anniston.

On October 24, 1940, Congress made appropriations of $12,400,000 for the construction of an ammunition storage plant near Fort McClellan. The area near Bynum was selected. The ground-breaking was held in February 1941 with Maj. Gen. Charles M. Wesson in attendance. The station was taken over in 1943 by the Anniston Warehouse Corporation, which remained in charge of the depot until September 3, 1945. When the military resumed control, Col. Clarence E. Jones became the depot commander.

The Anniston depot was assigned in April 1949 as the 3rd Army Area Distribution Depot for ordnance general supplies. During the Korean War, the number of employees doubled and an apprentice training program was added. The station also installed an automatic data processing system for stock control. The depot's mission is to perform maintenance on both heavy and light tracked combat vehicles and their components, in addition to performing maintenance on individual and crew-served weapons, combat missiles, and small arms. The Anniston Ordinance Depot operates with both government and civilian contract employees.

In 1898, Anniston resident Col. William H. McKleroy was instrumental in securing the establishment of Camp Shipp. The camp was located at Union Hill, near Seventeenth Street and Clydesdale Avenue, in northwest Anniston. The area was approximately where Union Foundry was located. The soldiers lived in tents that were made by taking three tents and fashioning them into one. The tents had partial boxed walls and floors constructed of wooden planks. For the winter of 1898, the tents were equipped with large heating stoves. In addition to the stoves, the men were also issued blankets. The 3rd Tennessee and the 2nd Arkansas encampments were northeast of the Woodstock Iron coke furnaces.

Camp Shipp fell under the jurisdiction of the 4th Army Corps based in Huntsville, AL, and under the command of Maj. Gen. Joseph Wheeler. The 4th Army Corps, 2nd Division, was headquartered in the Anniston camp under the command of Brig. Gen. R.T. Frank. The 2nd Division consisted of two brigades. The 1st Brigade, under Brig. Gen. G.S. Carpenter, consisted of the 4th Kentucky, the 3rd Alabama, and 2nd U.S. Infantry, while the 2nd Brigade, under Brig. Gen. L.W. Colby, was made up of the 2nd Arkansas, the 3rd Tennessee, and the 4th Wisconsin. The Provost, the law enforcement branch of the military, set up a camp at Thirteenth Street and Gurnee Avenue, next door to the city municipal building (shown above). Law and order in the military camp was the responsibility of the Provost.

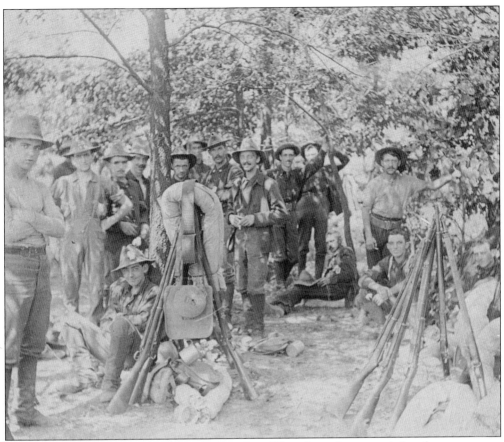

When hostilities ended in the Spanish-American War, the military needed a place to quarter troops until a peace agreement could be signed. Camp Shipp in Anniston was one of the sites to quarter troops. Anniston was selected to house troops for numerous reasons: rail connections to Mobile, a healthy climate, the organization of the city, and political pressure on influential congressmen by Annistonians. The hospital at Chickamauga Park, GA, was moved to Camp Shipp because of disease in the Georgia camp. Once the men arrived at Camp Shipp, the ill men seemed to improve, although there were reports of deaths from meningitis and a typhoid-like disease. The men also entertained themselves in various manors. The 2nd Arkansas had several quartets that entertained with music. There were several baseball teams within the regiments and the 4th Wisconsin was particularly good, since it was composed mainly of ex-professional baseball players.

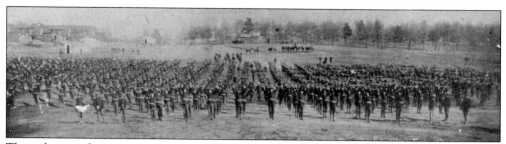

The volunteer divisions sent to Camp Shipp included the 2nd Arkansas, 4th Kentucky, 14th New York, 3rd Tennessee, and 4th Wisconsin. These were all white divisions, but the 3rd Alabama, an all African-American National Guard Infantry unit, was assigned to Camp Shipp as well. The units drilled daily on prepared drill grounds. Wooden kitchens and mess halls were built at the camp. A hospital was built by Oxanna contractor W.O. Grant and Company for $3,450. The 110-by-220-foot building included two isolation wards, a mess hall, a special diet kitchen, and a dispensary with an ambulatory unit at the opposite end of the hospital.

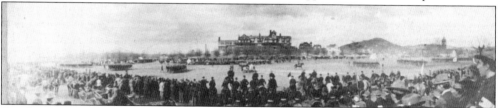

A military review of the Camp Shipp troops was a major event. Reviews took place on the open area in front of the Women's College, the old Anniston Inn. Most of Anniston, Oxford, and Oxanna turned out to watch the military reviews. Annistonians hoped that the military would make Camp Shipp a permanent military post. In March 1899, much of the hospital's supplies were shipped out and some of the shacks were demolished. It was clear by April 1899 that the post would close and the men would muster out. Even though Camp Shipp was gone, in 1912 the area was the site of the Southern States Maneuvers.

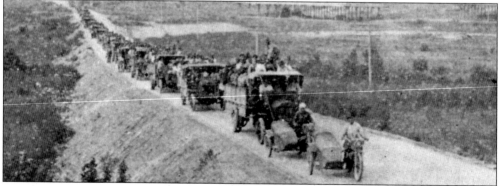

In 1917, the federal government bought 18,952 acres north of Anniston at a cost of $247,000 to start construction on the National Guard camp. Charles L. Dulin was in command of the construction quartermaster at Camp McClellan. Upon the completion of his survey, Dulin chose a section near Dark Corner, since the area had three major roads, fairly level terrain, and several creek tributaries flowing through. The land was also near the Southern Railway tracks. There were no towns to displace, since the area was largely agricultural; however, farmers lost approximately $136,000 worth of crops. Among the first things constructed at the camp was a 6-mile brick road that connected the camp with the city of Anniston. (Courtesy of *Anniston and Calhoun County, Alabama*.)

The Works Progress Administration (WPA) was instrumental in the building phase of Fort McClellan in the 1930s. The buildings, constructed in a Spanish Colonial Revival style, included the officers' quarters, non-commissioned officers' quarters, enlisted men's barracks, a fire station, guardhouse, truck park, repair shop, enlisted men's service club, gymnasium, Post Theater #1, a main post exchange, officers' club, Silver Chapel, and numerous other warehouses and workshops. During World War II, another building boom occurred at Fort McClellan, which was the site of the Infantry Replacement Training Center (IRTC). The IRTC was responsible for training replacement troops sent into combat. It was about this same time that Pelham Range, the previous sites of Peaceburg and Morrisville, was added to Fort McClellan.

In the early days of the camp, the men lived in tents with a stove or heater. The only constructed buildings were mess halls, showers, and latrines. The first division to train at Camp McClellan was the 29th Division. This unit trained at the camp until June 1918, when they were ordered to France, where they received heavy casualties during the Meuse-Argonne offensive. After World War I, Camp McClellan was placed in caretaking status, but by 1929 it was not only reactivated but designated as a fort, which gave the military installation permanent status. In the 1930s, the base underwent a major construction phase.

From July 1943 until the spring of 1946, Fort McClellan was home to 3,000 German prisoners of war. The camp, located just to the left after entering Baltzell gate, was divided into three compounds of 1,000 men each. Most of the men interned were part of Erwin Rommel's Afrika Corps and had been captured during the Africa campaign in 1943. The POWs worked on the base doing a variety of jobs to free up military personnel for the war effort. Several POWs were assigned to refurbish the Remington Hall Officer's Club (shown above). The horseshoe-shaped bar was hand carved by several of the prisoners. The murals on the walls were painted in 1944 and 1945 by POW artist Albin Sagadin of Würzburg and his assistant, Herbert Belau of east Prussia. The murals on the north, east, and west walls were the original works of the men. The mural on the south wall was added when the officer's club underwent renovation in the 1970s.

On June 30, 1947, Fort McClellan was placed in custodial status. However in 1950, the situation changed and the fort was selected as a National Guard training camp. Since the U.S. was involved in the Korean War, Fort McClellan was reactivated in 1951 to serve as the chemical corps school. In 1954, the Women's Army Corps (WAC) Center arrived at the fort. The WAC was eventually integrated into the Army and was dissolved in 1976. The military police school was moved to the fort in 1975 and the chemical corps school was relocated to the fort 4 years later. Throughout the years, Fort McClellan successfully fought off several attempts of base closure, but in the late 1990s its luck ran out. The base was closed on September 30, 1999, and personnel were relocated to Fort Leonard Wood, MO.

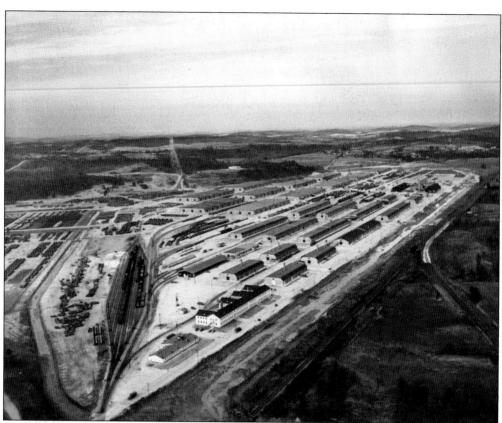

The Anniston Ordinance Depot (AOD) was originally planned as a supply dump and was part of the huge pre-war construction boom in 1940. The depot was located near Anniston because it had good rail links, a stable work force, and it was in a safe location away from enemy attacks. During World War II, the workers pulled long shifts in order to ship the tons of ammunition needed by the troops in Europe and the Pacific. Most workers had to travel to work at the depot, but some lived at De Soto Manor, a depot housing project with more than 300 units. The tiny two-room apartments were equipped with coal stoves for cooking and heating.

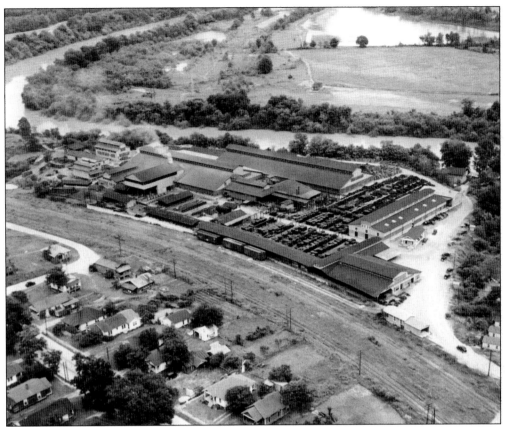

Like Fort McClellan, the AOD went into mothballs at the conclusion of World War II. When the Korean War broke out the depot was reactivated, but a reduction in workers hit in 1953 at the end of the war. The Cold War between the U.S. and the Soviet Union helped to keep depot workers employed. In the maintenance area there was a dynamometer test facility, a high-speed test track, and other specialized equipment. The Anniston Ordinance Depot's main shops are on a 5-acre section where tracked vehicles were overhauled. There were auxiliary shops to rebuild components from the tanks, refinish metal parts, reupholster, clean, paint, and do other necessary repairs. In addition to tank repair, the depot maintained shops to rebuild small arms, maintain missile systems, and work on other military materials.

The United Service Organizations (USO) grew out of the rapid increase of the U.S. military just prior to World War II. The organization sought to provide military personnel with a "touch of home" through morale, welfare, and recreational services. In 1940, six private service organizations pooled their resources and incorporated as the USO on February 4, 1941, in New York. The USO was not a government organization, but the President of the United States served as the honorary head of the organization. USO canteens were located all across the United States and by 1944 there were over 3,000 canteens. During World War II, there were several USO canteens in Anniston. One canteen was located on Twelfth Street between Quintard and Wilmer Avenues under the guise of the YMCA and another, located at 1407 Noble Street (pictured above), was run under the supervision of the Salvation Army. The Jewish Welfare Board was responsible for a canteen at Twelfth Street and Gurnee Avenue. A USO canteen for African-American soldiers was operated by the National Catholic Community Service at 720 West Fourteenth Street. By 1948, the Anniston canteens had closed and the buildings were used for local businesses. The USO is still an active organization that provides services to military personnel at home and abroad.

BIBLIOGRAPHY

Alabama Military Institute Prospectus, 1928–29. Montgomery, AL: Brown Printing Co.

Alabama Presbyterian College. *Select Views of Anniston.* N.p., n.d.

Anniston and Calhoun County, Alabama. Anniston, AL: Anniston Chamber of Commerce, n.d.

Anniston City Directory. Anniston, AL: 1887–1903.

Anniston City Directory. Birmingham, AL: R.L. Polk & Co., 1904–99.

"Anniston Files." Alabama Room, Calhoun County Public Library, n.d.

The Anniston Star. 1900–2000.

The Anniston Star 75th Anniversary Edition. November 20, 1957.

The (Anniston) Weekly Times. 1898–1899.

Bodenheimer, Ruth F. *The Founding of Temple Beth-El in Anniston, Alabama.* N.p., n.d.

East Alabama Regional Planning Commission Staff. *Comprehensive Plan for Anniston, Alabama.* Springfield, VA: U.S. Department of Housing and Urban Development, 1972.

Entire, Robert (ed.). *Anniston, Alabama Centennial 1883–1983 Commemorative Book and Centennial Program.* Anniston, AL: Higginbotham's Inc., 1983.

Hagerty, Julius Pinckney Jr. *Early History of the Industrial City of Anniston, Alabama, 1872–1889.* Auburn, AL: MA Thesis, Auburn University, 1960.

McAlester, Virginia and Lee McAlester. *A Field Guide To American Houses.* New York: Alfred A. Knopf, 1984.

McCaa, Samuel Noble. *Samuel Noble: Founder of Anniston.* Auburn, AL: MA Thesis, Auburn University, 1966.

"Oxanna File." Alabama Room, Calhoun County Public Library.

Parker, George, O. and Gail Stephens. "Architectural Heritage of Anniston." Anniston Council on the Arts and Humanities, 1976.

Reed, Mary Beth, Charles E. Cantley, and J.W. Joseph. *Fort McClellan: A Popular History.* Stone Mt., GA: New South Associates, n.d.

Spencer, Robert F., et al. *The Native Americans.* New York: Harper and Row, 1977.

Wikle, Dr. J.L. "History of Anniston." Alabama Room, Calhoun County Public Library. 1940.

Willett, Judge J.J. "History of Anniston." Alabama Room, Calhoun County Public Library, 1932.

Williams, Gertrude R. *The Origin and Early Development of Anniston.* Jacksonville, AL: Jacksonville State College Research Paper, 1959.

Whitehead, Catherine A. *Fifty Years of the Anniston City Board of Education.* Jacksonville, AL: Graduate Program Jacksonville State College. n.d.